Photo editing

made easy

First published in the UK in 2012 by Which? Books
Which? Books are commissioned and published by Which? Ltd, 2 Marylebone Road, London, NW1 4DF
Email: books@which.net

British Library Cataloguing in Publication Data
A catalogue record for this book is available from the British Library

ISBN 978 1 84490 131 9

1 3 5 7 9 10 8 6 4 2

The publishers would like to thank Sarah Kidner and the Which? Computing team for their help in the preparation of this book.

Images: Royalty-free images appear courtesy of Shutterstock, iStockphoto, Digital Vision and PhotoDisc. All other photographs copyright Lynn Wright (see also page 160).

Consultant editor: Lynn Wright
Project manager: Emma Callery
Designer: Blanche Williams, Harper-Williams Ltd
Proofreader: Sian Stark
Printed and bound by: Charterhouse, Hatfield
Distributed by Littlehampton Book Services Ltd, Faraday Close, Durrington, Worthing, West Sussex BN13 3RB

Essential Velvet is an elemental chlorine free paper produced at Condat in Périgord, France, using timber from sustainably managed forests. The mill is ISO14001 and EMAS certified.

For a full list of Which? Books, please call 01903 828557, go to www.which.co.uk, or write to Littlehampton Book Services. For other enquiries, call 0800 252 100.

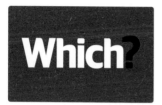

Photo editing

made easy

Contents

⊛ PERFECT FAMILY SHOTS

⊛ GET CREATIVE

EDITORIAL NOTE

The instructions in this guide refer to the Windows operating system and Adobe Photoshop Elements 8. Where other software or websites are mentioned, instructions refer to the latest version (at the time of going to print). If you have a different version, the steps may vary slightly.

Screenshots are used for illustrative purposes only.

Windows and Adobe are American products. All spellings on the screenshots and on the buttons and boxes in the text are therefore spelled in US English. The rest of the text remains in UK English.

All technical words in the book are either discussed in jargon busters within the text and/or can be found in the Jargon Buster section on pages 154–5.

INTRODUCTION

Digital photography means it's now easier than ever to take a huge collection of photos that capture your life – and the great thing about using a digital camera is that the creative possibilities don't end when you take the photo. Using photo-editing software, you can improve and alter your photos as much as you like, as well as use them in many creative projects.

Photo Editing Made Easy takes you on a step-by-step journey that helps you get more from your digital photos. Beginning with first steps that provide a firm grounding in editing and organising photos on your computer, this book then ventures into how to quickly and easily use photo-editing techniques to fix common photography problems. From cropping photos and removing red eye, to sharpening and brightening blurred and dull images, your photos will look better.

When you're ready for more adventurous tutorials, *Photo Editing Made Easy* can help you create those perfect family shots. There are handy guides on removing blemishes, whitening teeth, removing glare from glasses and even recomposing family photos.

For the more creative photographer, the step-by-step lessons let you have fun with your photos. From turning your modern photos into vintage-looking scenes, to adding 3-D effects and creating Pop Art-style posters, *Photo Editing Made Easy* can take your photos to the next level.

Photography is all about having fun, capturing and creating wonderful photos that you can share and enjoy in the years ahead. Now that you're ready to embark on your photo-editing journey, let's get started.

FIRST STEPS

By reading and following all the steps in this chapter, you will get to grips with:

▶ **Importing and organising photos**

▶ **Photoshop Elements' tools**

▶ **Working with selections and layers**

⏵ First Steps

GET TO GRIPS WITH PHOTO-EDITING

The great thing about digital photography is that the creative possibilities don't end when you take your photo.

With a conventional film camera, the only way to alter photos you've taken involves complex processing in a dark room. With digital photography, though, you can use photo-editing software on your computer to do simple changes such as enlarge, correct or improve your shots as well as create special effects, such as turning your photo into a sketch or watercolour.

TRY THIS
Photoshop Elements is a powerful photo-editor with lots of features but is still easy to get to grips with for both basic and advanced editing skill.

What can I do with photo-editing software?

Photo-editing programs let you make changes to photographs stored on your computer. You can edit prints that you've scanned in, such as old black-and-white pictures, or snaps taken with your digital camera. The software comes with a range of tools for correcting and manipulating your photos (see pages 11–13). In this book, information is provided for using Photoshop Elements 8.

How easy is a photo-editor to use?

Most photo-editing programs take practice to get to grips with, but many have automatic correction tools that do the work for you. The success of such tools can vary, however. The most powerful photo-editing programs have plenty of manual options, too, giving you the freedom to make precise adjustments. Or you may choose to ignore features, such as the histogram, which graphically displays the levels of different colours and light there is in an image.

Do I need a photo-editing program with all the features?

Many digital cameras are sold with simple photo-editing software; Windows Vista and Windows 7 also have some basic editing tools, which let you adjust exposure, colour and size, as well as remove red eye. The more sophisticated packages are jam-packed with filters and adjustable tools but it's unlikely you'll ever need or want to use the really advanced features, so you may prefer to opt for a cheaper, more basic photo-editing package.

Will my computer be powerful enough?

Some photo-editing packages – particularly those crammed with features – require relatively powerful computers. You'll need at least Windows 7 for most of them, for example.

Should I go for a paid-for program or a free download?

Most paid-for programs are available as boxed packages and come on a CD. The advantage of this is that should you need to reinstall the program for whatever reason, you can just pop the CD back in and reinstall it. You're also more likely to find that you get a printed manual in the box (though sometimes it's loaded on the CD).

TIP
Always check your computer meets the software's minimum requirements before you buy.

▶ It's often possible to find photo-editing programs cheaper online if you're prepared to shop around. Some programs are only available to download (in some cases free of charge).

▶ If you don't mind sacrificing some of latest features, you may well find an older version of a good program for a much lower price, too.

▶ Free downloads require a fast internet connection. Some are cut-down versions of paid-for programs so you're unlikely to get all the editing tools that are supplied with the paid-for versions.

▶ More comprehensive free-downloads are available too – designed by teams of volunteer developers. Compared to paid-for programs, you may find they are slightly harder to get to grips with.

⊙ First Steps

COMMON PHOTO-EDITING FEATURES

If you've never used a photo-editing program before, here's the lowdown on how it can help transform your photographs.

Manual and automatic tools

Good photo-editing programs come with both automatic and manual editing features.

▶ Automatic correction functions are very useful, but the results can be mixed, as the program has to make assumptions about how much colour and light there should be in the photo, and it doesn't always guess correctly.

▶ Most photo-editors have an 'undo' function, which lets you return your photo to its original state if you're not satisfied with the results of an adjustment.

▶ Manual tools give you the freedom to make precise adjustments. The more sophisticated photo-editing packages come with a huge array of filters and tools.

▶ While you should be able to get to grips with basic editing features quite quickly, expect a steep learning curve as you start to use more advanced features.

Red Eye Removal tool

We've all taken flash photos indoors only to find that all the people looking at the camera have developed demonic-looking red eyes. Red eye is caused when the light from a camera flash reflects off the blood-red tissue at the back of the eye.

▶ The trick to avoid this is to use the flash mounted off-camera, but that's not always possible, especially if you're using a compact camera.

▶ Thankfully, most photo-editing programs offer a Red Eye Removal tool, which works by cleverly replacing the red pupil with a more natural black one.

▶ Generally, you select the size of the area you want to correct and you can even add a glint to the eye to make it look more realistic (see pages 55–7).

Crop tool

The Crop tool is a common feature of photo-editing software. It lets you select an area of an image and get rid of everything else in the picture. Cropping is a quick and easy way to remove distracting elements, focus on one part of the scene or change a photo's proportions (see pages 42–4).

Spot Healing Brush tool

Some programs include scratch removal tools that can smooth over tears and creases you may find in an old photo you have scanned into your computer. The Spot Healing Brush is fine for smaller scratches, but more significant damage can be treated with the Clone Stamp tool (see below).

Clone Stamp tool

For those photos that would be perfect if it weren't for the complete stranger who walked into shot at the last minute, the Clone Stamp tool is an ideal solution. You can select an area of the background, for instance, and use it as a brush to 'paint' over the top of the unwanted bystander (see pages 68–70).

Resizing

You can use photo-editing software to resize digital photos, making them larger or smaller. This is useful when you need to reduce the size of a high-resolution photo taken by your camera to use it on the internet or to send it to friends and family via email (see page 33).

Colour and brightness

Many photo-editing programs let you adjust the lighting and colours. Advanced packages come with features that let you get more creative with your snaps (see pages 58–60).

Special effects

Many photo-editors offer a wide range of special effects that can create spectacular or downright bizarre results. Photos can be skewed and distorted in various ways or transformed into watercolour paintings or Warhol-like masterpieces (see pages 146–52).

DOWNLOAD AND ORGANISE PHOTOS

It's easy to download your photos direct from your digital camera or memory card into Photoshop Elements using the program's built-in 'Photo Downloader'. You can even set the 'Photo Downloader' to detect a memory card reader or digital camera when you attach it to the computer's USB port and then automatically download photos.

1 Connect your camera or card reader to your computer and switch on the camera

2 The 'Windows AutoPlay' box opens with a list of options for getting the photos. Click **Organize and Edit** and then click **OK**

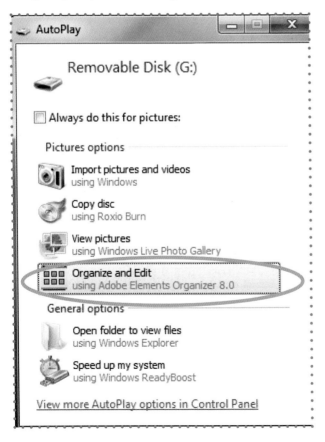

First Steps

3 If 'Elements Organizer' is not already open, the 'Photo Downloader' box opens

4 If you have 'Elements Organizer' open already, click **File**, then **Get Photos And Videos**, and then **From Camera Or Card Reader** to open the 'Photo Downloader'

TRY THIS
To automatically download photos to Photoshop Elements after a device is connected, select 'Automatic Download', which will open when you connect your camera or memory card.

Elements Organizer - Photo Downloader ✕

Source

Get Photos from:

G:\<Camera or Card Reader> ▼

150 Files Selected - 678.1MB
06/01/2008 - 14/04/2008

Import Settings

Location: C:\...\Pictures\[10 subfolders] Browse...

Create Subfolder(s): Shot Date (yyyy mm dd) ▼

Rename Files: Do not rename files ▼ +

Example: CIMG4010.JPG
☐ Preserve Current Filename in XMP

☑ Open Organizer when Finished

Delete Options: After Copying, Do Not Delete Originals ▼

☐ Automatic Download ♡

Advanced Dialog Get Photos Cancel

5 Choose from the **Get Photos From** menu to specify where to copy/import the photos from

Creating settings

You can also set the following download options:

1 Location This lets you specify a folder to which images are downloaded. To change the default folder location, click **Browse**, and choose a location on your hard drive

2 Create Subfolder(s) You can create a subfolder using the naming scheme chosen from the pop-up menu. If you choose **Custom Name**, type a subfolder name in the box

3 Rename Files This will change the filenames of the photos using the naming scheme that you select from the pop-up menu, such as the shot date or a custom name plus shot date. By clicking on **Custom Name** you could also type in your own name and a starting number for assigning sequentially numbered filenames to the photos

4 Preserve Current Filename In XMP Tick this box to use the current filename as the filename is conveniently stored in the metadata of the photo

5 Delete Options Here you can choose whether to leave the photos on your camera or card, delete them before importing them, or delete the files after they're copied

Elements Organizer - Photo Downloader

Source

Get Photos from:
G:\<Camera or Card Reader>
150 Files Selected - 678.1MB
06/01/2008 - 14/04/2008

Import Settings

Location: C:\...Pictures\[10 subfolders] Browse...

Create Subfolder(s): Shot Date (yyyy mm dd)

Rename Files: Do not rename files
+
Example: CIMG4010.JPG
☐ Preserve Current Filename in XMP

☑ Open Organizer when Finished

Delete Options: After Copying, Do Not Delete Originals
☐ Automatic Download

Advanced Dialog Get Photos Cancel

▶ First Steps

Using further options

1 For more download options, click the **Advanced Dialog** button at the bottom left to expand the window and reveal thumbnails of all the photos on the memory card (as shown below). The 'Advanced Dialog' box offers all the options in the 'Standard Dialog' box plus several additional ones. For example, you can view all of the media files stored or preview videos before importing them

2 You can also add information in the 'Apply Metadata' box (see Step 3), specify an album for the imported photos, and automatically fix red eye as the images are imported. The settings you specify in this box remain the same until you reset them

3 Use the **Apply Metadata** option if you intend to share images over the web or, perhaps submit photos to magazines for publication or competitions. Type your name and copyright information into the text fields, and they'll be embedded in each of the download images from your memory card

4 There may be times when you don't want to download all the images on the memory card. You will see a tick underneath each of the thumbnails. Click the checkbox at the bottom right of the thumbnail of those you *don't* want to import

Downloading

When you're happy with your settings, click **Get Photos**. 'Elements Organizer' will open and import the photographs. The window will then show only the photos you have imported, as below. Click **OK.**

⊙ First Steps

EDIT USING PHOTOSHOP ELEMENTS

Photoshop Elements is two programs in one: a photo-editor and an organiser. You can view, print and do basic edits in the organiser, but most photo-editing tasks need to be done in the image window in which photographs automatically open.

Open pictures in Photoshop Elements

1 Click **Start**, then **All Programs**, and then **Adobe Photoshop Elements 8**. On the 'Welcome' screen click **Edit**

2 Click **File** and then **Open** and browse your computer's hard disk to locate the photo you wish to open. Select a photo and click **Open**. The photo will now appear in the image window

3 Click and drag on the bottom-right corner of the window to resize the window but without resizing the photo on screen

4 To view the photo at a different size, click **View** from the top menu bar and select either **Zoom In**, **Zoom Out**, **Fit on Screen** and **Actual Pixels**. Keyboard shortcuts are listed next to each setting and learning these will help speed your editing as you then don't need to move the cursor around the screen so much, using key combinations instead

5 To close a photo, click **File** and then **Close**. If you have made any changes to the photo, a pop-up window will ask you if you wish to save the photo before closing it

▶ First Steps

NAVIGATE THE ELEMENTS INTERFACE

When using Photoshop Elements 8 for photo-editing, it's useful to become familiar with the program's workspace and interface. This way you'll know where to find your photos and the tools and panels to work with.

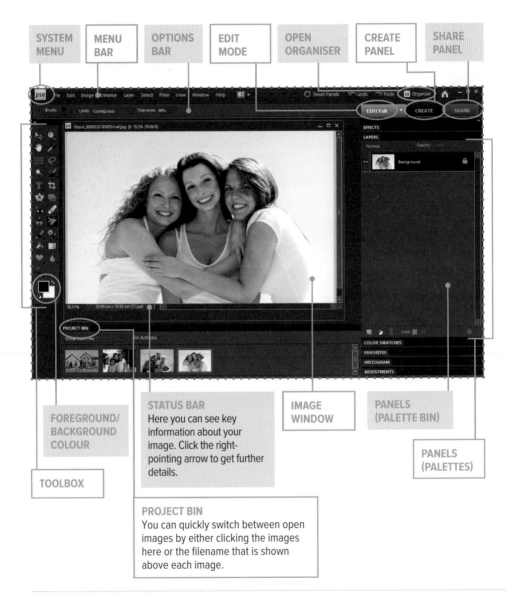

SYSTEM MENU

MENU BAR

OPTIONS BAR

EDIT MODE

OPEN ORGANISER

CREATE PANEL

SHARE PANEL

FOREGROUND/ BACKGROUND COLOUR

TOOLBOX

STATUS BAR
Here you can see key information about your image. Click the right-pointing arrow to get further details.

IMAGE WINDOW

PANELS (PALETTE BIN)

PANELS (PALETTES)

PROJECT BIN
You can quickly switch between open images by either clicking the images here or the filename that is shown above each image.

20

Photoshop Elements comes with three workspaces or modes that let you edit photos. Click the triangle beside 'EDIT Full' and select from the following options:

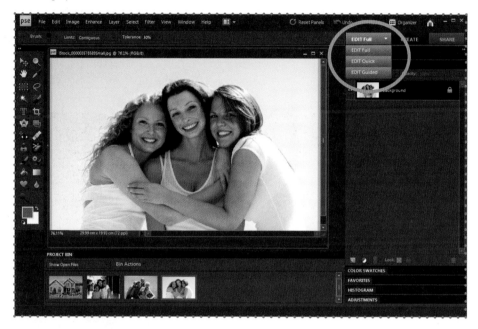

EDIT Full The 'Full Edit' workspace has tools to correct colour problems, create special effects and enhance photos.

EDIT Quick The 'Quick Fix' workspace has simple tools for correcting colour and lighting, as well as commands that can quickly fix common problems such as red eye.

EDIT Guided The 'Guided Edit' workspace provides step-by-step guidance on how to perform common tasks, such as rotating and straightening photos and making colour corrections.

If you're new to photo-editing, the 'Quick Fix' or 'Guided Edit' workspaces are good places to start.

TIP
For a quick way to zoom into your photo to see areas in detail, hold down the **Ctrl + spacebar** keys and click. Zoom back out by holding down the **Alt + spacebar** keys and click.

WORK WITH SELECTIONS

One of the great advantages of photo-editing software is the ability to make changes to just part of a photo. You may for example want to change the colour of an object or remove it from the photo entirely.

With Photoshop Elements this type of edit is easy. First you need to mark the part of the image you wish to edit. This is done by making a selection, using one of Element's selection tools. When you make a selection, it will be shown by a dashed line border (also know as 'marching ants'). You can then fine-tune your selection by adding areas to or subtracting areas from it, as well as expand, contract or move it.

Once you've made a selection, you can then change, copy, or delete pixels within the selected area, but the rest of the photo remains unchanged. Before you can make changes to the rest of the photo, you must first deselect the selection.

Selection tools

Photoshop Elements has several selection tools located in the toolbar on the left side of the window. Which one you use depends on the type of selection you're making. For example, if you wish to select the wheels of a car or some other round object, then the Elliptical Marquee tool is best as it selects circular areas.

Photoshop Elements' selection tools are as follows:

Rectangular Marquee tool Use this for square or rectangular selections, such as the windows or the door of a house.

Elliptical Marquee tool Use this for circles or elliptical selections such as car wheels.

Lasso tool Use this for drawing freehand selections, as it's good for making precise selections.

Polygonal Lasso tool Use this for creating multiple straight-edged segments of a selection such as drawing around a house and garage.

Magnetic Lasso tool This creates a selection border that automatically snaps to edges when you drag over areas in the photo. It's good for quickly selecting objects that have complex edges set against high-contrast backgrounds, for example a yellow flower set against a blue coloured background.

Magic Wand tool This selects pixels of a similar colour with one click, for example selecting blue sky behind a person or object.

Quick Selection tool Use this to quickly create a selection based on colour and texture when you click or click-drag an area. You don't need to be precise when marking the area, because this tool automatically and intuitively creates a border.

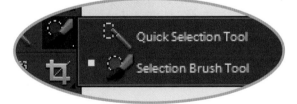

Selection Brush tool This automatically selects the area you paint.

Smart Brush tool Use this to make colour and tonal adjustments to a selection (see pages 64–7). It automatically creates an adjustment layer so you can easily change your mind about alterations without permanently affecting your photo.

⏵ First Steps

MODIFY SELECTIONS

Making the perfect selection in one go is tricky even for experienced photo editors. Fortunately, Photoshop Elements 8 has several tools that help you to adjust the selection you're making. These are found in the options bar when you have clicked one of the selection tools or in 'Select' menu. Here are some of the ways you can fine-tune your selection:

Add to or subtract from a selection
Regardless of the selection tool you've used, you can add or remove areas of your photo from the selection.

1 Click a selection tool and select part of the image

2 In the options bar, click the **Add to selection** icon (or hold down the **Shift** key), then select an area of the image to add to the selection

3 To remove an area from the selection, click on the **Subtract from selection** icon in the options bar (or hold down the **Alt** key) and select an area to remove it

Expand or contract a selection

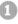 Click a selection tool and select part of the image

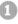 From the top menu click **Select**, then **Modify** and then **Expand...**
or **Contract...**

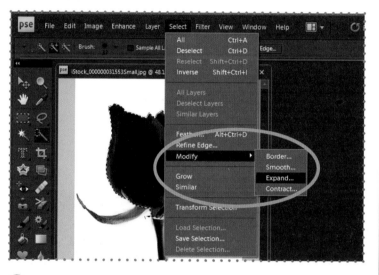

BE CAREFUL

When clicking anywhere in the photo outside the selection area to deselect it, you could accidentally make another selection if you're using a selection tool that selects based on clicking, such as the Magic Wand tool. The safest way to deselect the area is to choose **Select**, then **Deselect**.

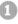 In the 'Expand (or 'Contract) Selection' dialog box enter a number of pixels between 1 and 100

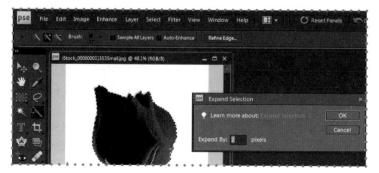

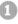 Click **OK**. The selection border will expand or contract by the number of pixels you specified

▶ First Steps

TRY THIS

Sometimes it's easier to select an area of a photo that you don't want to edit rather than the part you do. Do this and then invert the selection to change the unselected area into the new selection. Click **Select**, then **Inverse**.

Smooth the edges of a selection

You can smooth the hard edges of a selection by anti-aliasing or feathering (see below). Anti-aliasing is useful when cutting, copying and pasting selections to create composite images. It smoothes a selection's jagged edges by softening the colour transition between the background and the edge pixels. As only the edge pixels are altered, you won't lose detail in the selected part of your photo.

You can use anti-aliasing with the Lasso, Polygonal Lasso, Magnetic Lasso, Elliptical Marquee and Magic Wand tools. Anti-aliasing can't be added to an existing selection, you must choose it before making a selection.

1 Open a photo you wish to work on. Select the **Lasso**, **Polygonal Lasso**, **Magnetic Lasso**, **Elliptical Marquee** or **Magic Wand** tool

2 In the options bar, select **Anti-alias**

3 Make a selection on your photo

Feather a selection edge

You can also smooth a selection's hard edges by feathering. Unlike anti-aliasing, feathering blurs edges between the selection and surrounding pixels resulting in some loss of detail at the edge of the selection. Some selection tools let you choose feathering before you make a selection: the Elliptical Marquee, Rectangular Marquee, Lasso, Polygonal Lasso or Magnetic Lasso tools. Simply select the tool and enter a 'Feather' value in the options bar to define the width of the feathering.

You can also feather an existing selection using the 'Select' menu. The steps opposite explain how to do this.

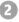 Open a photo you wish to work on, then click a selection tool and make a selection

② Click **Select**, then **Feather...**

③ Type a value between .2 and 250 in the 'Feather Radius' box. This defines the width of the feathered edge

④ Click **OK**

Select and deselect areas using the Select commands

▶ To select all pixels in the image, click **Select**, then **All**.

▶ To deselect selections, click **Select**, then **Deselect**.

▶ To reselect the most recent selection, click **Select**, then **Reselect**.

▶ To show or hide selection borders, click **View**, then **Selection**.

▶ First Steps

TRY THIS
Using multiple layers will increase the file size of your image significantly. You can reduce the file size by merging layers when you've finished editing.

WORK WITH LAYERS

A powerful feature of many photo-editing packages, layers are the digital equivalent to laying sheets of tracing paper or transparent plastic over the top of a photo. They can be created and deleted by you (see below and opposite) and can be used to add other images, text or special effects to a photo, safe in the knowledge that your original photograph is protected. You can work on each layer independently to create the effect you want and each layer remains independent until you merge (flatten) the layers (see page 30).

Layers are organised in the 'Layers' panel. The bottom-most layer is your original photograph and is called the 'Background' layer. By default, this is locked (protected) so your original photo is safeguarded.

Your options when using layers
Once you have mastered the principle of using layers, as explained on these two pages, you can go on to create all sorts of different effects. For example, you can:
- ▶ Change colours (see pages 64–7)
- ▶ Merge part of one picture with another (see pages 80–1)
- ▶ Add text to a photo (see pages 112–13)
- ▶ Create blur effects (see pages 114–18)
- ▶ Apply lighting effects (see pages 119–23)
- ▶ Enhance a panoramic photo after it's been stitched together (see pages 124–7).

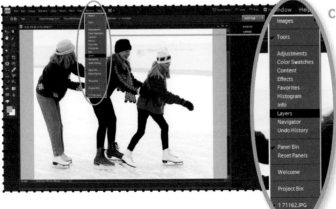

Create a layer

1 Open a photo you wish to add layers to

2 Click **Window** and then **Layers** to open the 'Layers' panel

 To create a layer with default name and settings, click on the drop-down arrow next to the 'Layers' tab and then **New Layer....** The new layer uses 'Normal' mode with 100% opacity (variables that are explained later in the book when appropriate), and is named according to its creation order 'Layer 1', 'Layer 2' and so on

 To rename the new layer, double click it and type a new name into the highlighted box

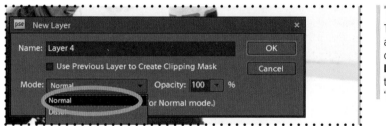

TIP
To quickly open a new layer, click on the **New Layer** button at the bottom of the 'Layers' panel.

 If you want to create a layer and specify a name and options, choose **Layer**, then **New** and then **Layer**, or choose **New Layer** from the 'Layers' panel menu. Type in a name and other options, and then click **OK**

 The new layer is automatically selected and appears in the panel above the layer that was last selected

Delete a layer
Drag the layer to the 'Delete Layer' icon at the foot of the 'Layers' panel or click the **Delete Layer** icon at the bottom of the 'Layers' panel, and click **Yes** in the delete confirmation box

Select a layer

 In the 'Layers' panel, select a layer's thumbnail or name

 To select more than one layer, hold down **Ctrl** and click each layer

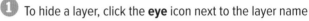
Show/hide a layer

In the leftmost column of the 'Layers' panel is an eye icon next to each layer. This means that the layer is visible.

1 To hide a layer, click the **eye** icon next to the layer name

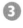

LAYERS

Normal ▼ Opacity: 100%

Layer 3

Layer 1

Background 🔒

2 To show a layer, click in the same place next to the layer name and the eye icon reappears

3 To show just one layer, press **Alt** and click the **eye** icon for that layer. Repeat **Alt-click** in the eye column to show all the layers

Merge layers

Once you are happy with the additional layers, merge them with the background. This is also known as flattening: right click on **Layers** and choose 'Flatten Image'.

FIX COMMON PROBLEMS

By reading and following all the steps in this chapter, you will get to grips with:

 Resizing and resampling photos

 Cropping and straightening photos

 Removing red-eye and sharpening photos

UNDERSTAND RESOLUTION

View a digital image in extreme close-up and you'll see that it is made up of millions of tiny squares of colour arranged next to each other on a grid. These tiny squares are called pixels (an abbreviation of 'picture element'). When viewed at normal size, these pixels form a recognisable image.

Pixels are used to describe the size of a digital photograph. Image size is a measure of the number of pixels along a photo's width and height. So, for example, your digital camera may take a photo that is 4,000 pixels wide and 3,000 pixels high. These measurements are also an indication of the amount of image data in a photo and how big it is in terms of file size.

TIP

Viewing your images on a computer screen is no indicator of print quality. This is because screens display images at 72ppi (pixels per inch), but for a good quality print you need to print on photo paper at 300ppi.

The term resolution is usually used to describe the number of pixels in a digital image. It's measured in pixels per inch (ppi): the more pixels there are, the greater the resolution. In turn, the higher the resolution of a photo, the better it will look when printed at a large size.

With a high-resolution photo, you can choose to use just part of the photo for the final print or zoom into a specific area. The more you zoom into a digital photo, the less smooth it will appear. By starting with a higher resolution, you can keep this jagged appearance at bay when zooming into part of a photo.

While a digital photo has a set amount of pixels (determined by the digital camera that took the shot), it doesn't have a fixed physical size or resolution. Size and resolution have a direct correlation to each other – as you change one, the other changes accordingly. So, for example:

▶ If you change a photo's resolution, its physical dimensions change.
▶ If you change the photo's width or height, its resolution will change.

CHANGE THE SIZE OF A PHOTO

If you want to change the size of a photo, you can use Photoshop Elements to either resize or resample it.

▶ Resizing changes the size of a photo without changing the number of pixels.

▶ Resampling changes the number of pixels in a photo – usually to make the photo a certain size or resolution.

With resampling, you can remove pixels (known as downsampling) or add pixels (known as upsampling). Resampling to smaller dimensions preserves image quality and reduces your photo's file size (see page 34). Upsampling a photo usually results in poorer image quality with a loss of detail and sharpness. This is because Photoshop Elements has to make an educated guess when adding pixels that weren't originally captured by your digital camera (see page 36).

To check the size of your photo, click **Image**, **Resize** and then **Image Size**. This shows the 'Image Size' dialog box, which has two main sections: 'Pixel Dimensions' and 'Document Size'.

▶ The 'Pixel Dimensions' shows the width and height of a photo in pixels as well as the file size of the photo.

▶ The 'Document Size' shows the size of the photo when printed at a specific resolution. For example, at 300 pixels per inch you can print the photo at a 6 x 4 inch size.

The 'Image Size' dialog box has three checkboxes: 'Scale Styles', 'Constrain Proportions' and 'Resample Image'. The first two options are only available when the 'Resample Image' box is checked.

▶ Fix Common Problems

TIP

If you want to change the width and height of an image size independently of each other, uncheck the 'Constrain Proportions' checkbox.

Selecting 'Resample Image' allows Photoshop Elements to add or remove pixels from your photo. 'Scale Styles' only matters if you've altered your photo using layers and effects such as shadows. With the button checked, these effects will scale proportionally with the photo when it's resized. 'Constrain Proportions' is ticked by default. It links the width and height of the photo so that if you change one, the other changes automatically and the photo's proportions stay the same.

Shrink photos for email

If your digital camera is taking photos using high quality or fine settings, the resulting photo files can be too big to sensibly share with friends and family using email, but resizing can quickly be done.

1 Open a photo you wish to resize

2 Click **Image**, followed by **Resize** and then **Image Size...** from the top menu

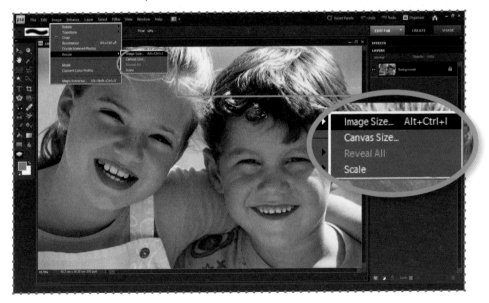

3 In the 'Image Size' box make sure that **Scale Styles**, **Constrain Proportions** and **Resample Image** are all ticked

4 Type the width of the image you want into the top field labelled **Width**. This is usually a measurement in pixels – in this case, a width of 600 pixels is fine for most photos you want to email. The **Height** value will automatically change as you type. Press **OK**

5 Choose **File** and then **Save For Web…**. On the far-right pane, choose **JPEG** from the drop-up menu, and choose **High** from the pop-up menu underneath. Use the 'Quality' slider to set the quality to 60. Click **OK**. When prompted, choose where you want to save your now much smaller, resized photo

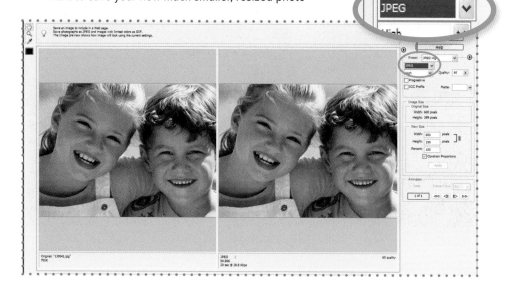

▶ Fix Common Problems

Enlarge photos

While it's possible to make photos bigger in photo-editing software, it is best avoided as the computer software has to 'guess' at the missing detail that a photo needs to increase its size. However, if you need to enlarge a photo to print it at a big size, there are some steps you can take to get a better result.

1 With your photo open, choose **Image**, then **Resize**, and then **Image Size** from the menu. In the **Image Size** box, make sure that **Scale Styles**, **Constrain Proportions** and **Resample Image** are all ticked

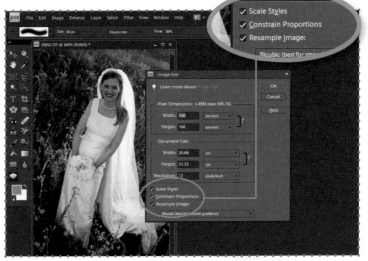

2 Ensure that the pop-up menu next to 'Resample Image' has **Bicubic** selected

3 Increase the width of the image, changing the **Width** setting in the pop-up menu to **percent**. In the **Width** field, enter a value up to around 200%. Any larger than 200% will significantly blur the image

4 Choose **File** and then **Save**. If you wish to keep the original photo, click **File** and then **Save As** and give the different-sized version a different name

ELEMENTS' QUICK FIX TOOLS

Photoshop Elements' Quick Fix tools let you alter a photo's brightness and colour and make it look sharper with just a click or two. They make it very easy to whiten a person's teeth, make the sky more blue or even turn all or part of a photo into black and white. The Quick Fix workspace is great for beginners as you don't even need to understand what you're doing – simply click a button or move slider to achieve the effect you want.

Even if you have photo-editing experience, you may still wish to use these tools for adjusting shadows and highlights or making other changes because this workspace gives you a handy before-and-after view.

TIP
For extra help use Element's Guided Edit workspace, which walks you step by step through many basic photo-editing tasks.

Access the Quick Fix workspace

1 Open a photo you want to work on. Click the **EDIT Full** tab and choose **EDIT Quick**. The 'Quick Fix' workspace looks like a stripped-down version of the 'EDIT Full' window, with eight tools on the left and a collection of quick-edit panels inside the 'Panel bin' on the right

2 Select an option from the 'View' menu, which is positioned just below the image window. 'Before & After – Horizontal' or 'Before & After – Vertical' are best for deciding if your photo edits work well

3 After choosing a 'View' option, click **Fit Screen** to make sure the 'Before' and 'After' views show the entire image

Use the Quick Fix panels

There are a couple of ways to apply a 'Quick Fix' adjustment to a photo. In the panels on the right-hand side you can do one of the following:

▶ Click the **Auto** button.

▶ Use the sliders to make an adjustment.

▶ Click the **Quick Fix** preview icon beside the slider (it looks like a 9-square grid) to see thumbnails of the presets available. Move your cursor over a thumbnail to see a preview of the adjustment. Click the thumbnail to select it.

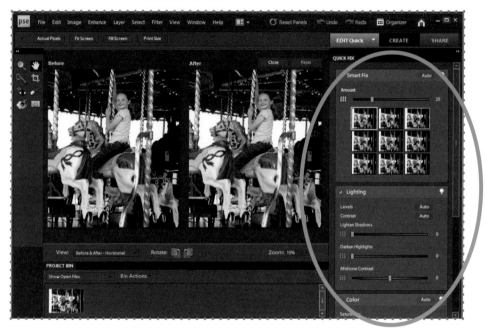

When you use the sliders or a preset to make a change, you'll need to click the **Commit** button (green check mark) to apply the adjustment, or **Cancel** (the red cross) to cancel the change.

The 'Quick Fix' panels offer the following editing tools:

Smart Fix This corrects a photo's overall colour balance and, if necessary, improves shadow and highlight detail.

Lighting This adjusts the overall contrast of a photo, which can affect its colour. You can click the auto buttons for 'Levels' or 'Contrast':

▶ 'Levels' changes the darkest pixel in the photo to true black and the lightest one to true white, spreading out all the other pixels in between. Use this to remove a photo's colour cast (see pages 48–9).

▶ 'Contrast' does the same thing but doesn't affect a photo's colour. Use it to boost the contrast between light and dark areas.

You can also use the sliders to darken highlights, lighten shadows or adjust the midtones – the mid tonal areas between highlights and shadows.

Color Click the **Auto** button to adjust a photo's colour. You can also use the 'Saturation' slider to make colours more vibrant or muted, and the 'Hue' slider to change all the colours in the photo.

Balance Here you can alter a photo's colour balance without affecting contrast:

▶ The 'Temperature' slider makes the colours warmer (more red) or cooler (bluer) – useful for adjusting skin tones.

▶ The 'Tint' slider makes the colour more green or more pink and is best used to fine-tune colours after using the 'Temperature' control.

Detail Here you can adjust the sharpness of your photo. Click **Auto** to use the default level of sharpening or drag the 'Sharpen' slider to vary the amount of sharpening.

fix common problems

⏵ Fix Common Problems

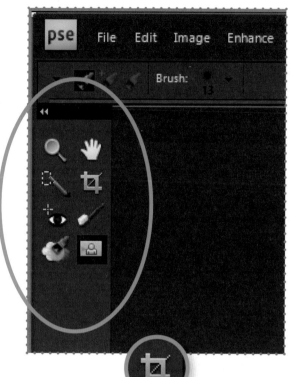

The Quick Fix toolbar
The Quick Fix toolbar holds a subset of the 'Full Edit' window's larger tool collection. Tools include:

Zoom tool Lets you zoom in and out on your photo.

Hand tool Lets you grab a photo and move it around in the image window.

Quick Selection tool By making a selection, you can apply 'Quick Fix' adjustments to specific areas of your image.

Crop tool Lets you remove areas of a photo.

There are also four touch-up tools that let you apply corrections and adjustments to selected parts of a photo. Apart from red-eye removal, all these buttons' changes are applied on an adjustment layer (see pages 28–30) so the original photo remains untouched. This means you can try different adjustments without affecting your original photo. The touch-up tools include:

Red Eye Removal tool Lets you remove the red flash reflections in people's eyes (see pages 55–7).

Whiten Teeth Lets you transform yellow or dull teeth (see pages 88–9).

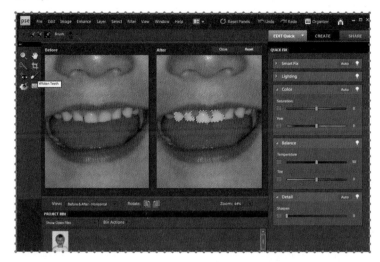

Make Dull Skies Blue Applies a 'Blue Skies' adjustment. Drag in the image where you want to add blueness to the sky.

Black and White – High Contrast This simulates the effects that photographers produce by placing a red filter over the camera lens and using monochrome film (see pages 98–100).

▶ Fix Common Problems

CROP PICTURES

One of the fastest and simplest ways to improve a digital photo is to crop it. Cropping is the process of removing a part of the photo so the focus is where you want it to be. For example, you may wish to remove an ugly object or unwanted person from the background of a shot or crop out empty space around your subject. Here's how to do it.

1 Open a photo you wish to crop

2 On the toolbar click the **Crop** tool

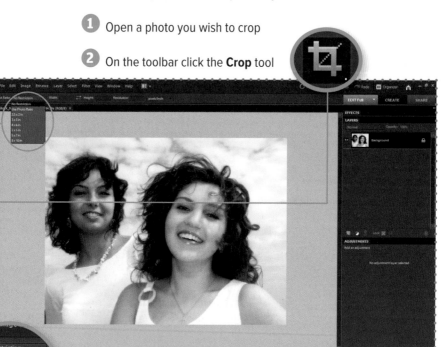

3 In the options bar, click the crop options you want. Leave the default aspect ratio set to **No Restrictions** as this lets you crop the photo to any shape or size you want.

▶ If, however, you want to create a standard sized photo, click on the box next to 'Aspect Ratio' and select a photo size such as 4 x 6 inch from the drop down menu. Leave the 'Resolution' box blank so that when the photo is cropped, the correct resolution for the area is determined for you

▶ Alternatively you can enter a custom width, height, or resolution for your cropped photo

Aspect Ratio: No Restriction ⇄ Width: ⇄ Height: Resolution: pixels/inch ▾

4 Place your cursor where you want the top-left corner of the crop to start and click and hold down your mouse button. Then drag your mouse to where you want the crop to end and release the button. The area of the cropped photo will be highlighted and the area outside will be dimmed

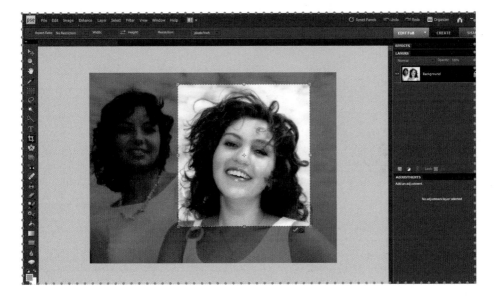

5 If you're not happy, you can adjust the crop:
 ▶ Either by clicking within the cropped area and dragging the rectangle around your photo, you can position the crop area exactly where you want it to be
 ▶ Or by clicking and dragging on any of the handles (the small squares at each corner and halfway along each edge of the crop box) to change the size and shape of the cropped area

⏵ Fix Common Problems

TRY THIS
You can also use the crop to select just one person from a group shot or crop a photo to a specific size.

6 When you're happy with the crop area, click the green **commit** button or press **Enter** to complete the crop

7 Click **File** and then **Save** to save the new cropped image. If you wish to keep the original photo, click **File** and then **Save As** and give the cropped version a different name

STRAIGHTEN PHOTOS

One of the benefits of using a digital camera is that you can snap away and capture shots you might otherwise miss. Yet this spontaneous approach to photo taking can mean you don't take the time to set up your shots or use a tripod and the end result can be a crooked photo.

1 Open a photo you wish to straighten

2 Click the **Straighten** tool

3 On the option bar, click on **Canvas Options** and choose an option from the pull-down menu:

- ▶ 'Grow or Shrink Canvas to Fit' resizes the background to fit the rotated image. The straightened image will contain areas of blank background, but no pixels from the photo are removed
- ▶ 'Crop to Remove Background' crops the image to remove any blank background area that becomes visible after straightening
- ▶ 'Crop to Original Size' keeps the canvas the same size as the original image. The straightened image will include areas of blank background and some pixels will be removed

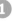
Use 'Grow or Shrink Canvas to Fit'

1 Set the 'Canvas Option' to **Grow or Shrink Canvas to Fit**. Locate a line within the photo that will serve as a straightening guide. In this case, it's the horizon

2 Using the **Straighten** tool, click and hold down the mouse button to drag along this line right to the edge of the photo. Release the mouse button and a dotted line will appear

3 Photoshop Elements will now rotate your photo to make that line horizontal. In doing this, empty wedges of canvas background can be seen (see opposite)

4 To remove these, use the **Crop** tool (see below). This approach offers greater flexibility in choosing the final look and aspect ratio of your photo than using Photoshop Element's automated 'Crop To Remove Background' option

Use the Crop tool

1 Click the **Crop** tool from the toolbox

2 Click and drag inside the photo to draw a rectangular selection, making it as large as possible without including any of the empty background wedges

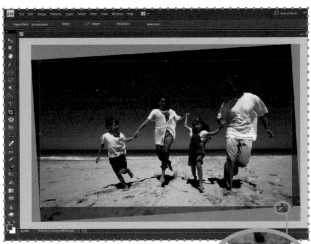

3 Click the green **commit** button that appears in the tab at the bottom-right corner of the crop selection box or press **Enter**

Fix Common Problems

4 Everything outside the crop selection box is removed and the result is a photo that appears straight, as seen below

5 Click **File** and then **Save** to save your photo. If you wish to keep the original photo, click **File** and then **Save As** and give the straightened version a different name

REMOVE COLOUR CAST

If the colours in your digital photo look less than realistic, it may be the result of a colour cast. This is simply an unattractive colour shift that sees an overall colour tone, usually yellow, applied to the photo. It often happens when using a built-in flash, or when a photo is taken indoors without a flash. Here's how to tone down or remove colours casts.

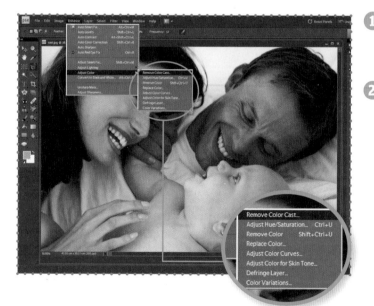

1 Open a photo you wish to work on

2 On the top menu bar click **Enhance** and from the drop-down menu, click **Adjust Color** followed by **Remove Color Cast**

3 Click an area in your photo that should be white, black or grey. The colours in your photo are then adjusted based on the colour you selected

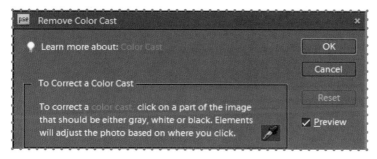

4 Click **OK** to accept the colour change

5 Click **File** and then **Save** to save your photo. If you wish to keep the original photo, click **File** and then **Save As** and give the different coloured version a different name

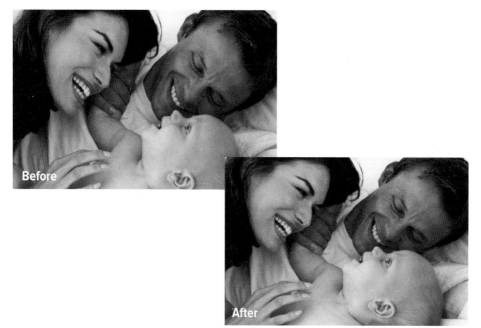

⊙ Fix Common Problems

TRY THIS

If you're processing a number of images with similar noise levels, Photoshop Elements remembers the last filter used and its settings before it's closed. To apply the same settings to the next image, click on **Filter**, then **Reduce Noise**.

REDUCE NOISE

When you're taking photos indoors or under low light without a flash, you'll almost certainly need a high ISO setting to prevent blur from camera shake. However, this increase in camera sensor sensitivity, either automatically or by using manual selection, will inevitably result in raised noise levels, leading to off-putting coloured blotches and speckles on your photos. To overcome this problem:

1 Open a photo that has high levels of digital noise or, to check for noise in images, double click the **magnifying glass** icon to view at 100%

2 Select **Filter**, then **Noise** and then **Reduce Noise**. This brings up the 'Reduce Noise' box complete with three sliders to adjust, each of which are described in Steps 5 and 6:
- ▶ Strength
- ▶ Preserve Details
- ▶ Reduce Color Noise

as well as a preview pane at 100%

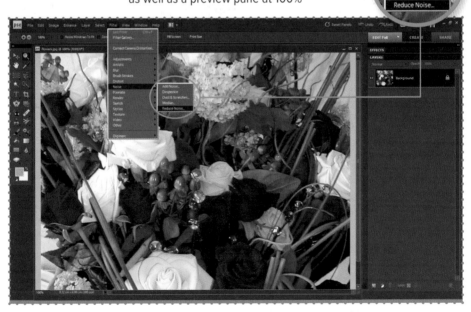

3 Click and drag the preview image to reposition the image for a clearer view of the blotches and speckles. By default, the filter applies some moderate noise reduction, so making additional adjustments with the sliders to the left or right of the defaults will, respectively, reduce or increase the effect

4 To view the change before and after making any adjustments, click and hold the preview image

5 Should the colour blotches be quite noticeable after the initial adjustment, drag the 'Reduce Color Noise' slider up to around the 70 to 80% level. Click and hold the preview pane in order to gauge the effect

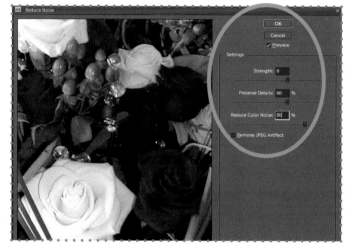

6 If the image still looks grainy, drag the 'Strength' slider further to the right. This will soften the photo quite considerably, but if you pull the 'Preserve Details' slider to the right, in small steps, some detail will return. Take care not to overdo it, though, as noise will reappear. Unless you can see artifacts such as blocks or tiles appearing in your image (at 100%), you can leave the 'Remove Jpeg Artifact' box unchecked

TRY THIS
If the preview image takes some time to refresh, uncheck the **Preview** checkbox, then select it again straightaway.

7 Click **OK** to apply the changes

8 To save your changes, click **File** and then **Save.** If you wish to keep the original photo, click **File** and then **Save As** and give the sharpened version a different name

▶ Fix Common Problems

SHARPEN PHOTOS

With digital technology the photos your camera captures can appear slightly soft. You may not notice this at first, but if you sharpen a photo in a photo-editor, the effect is obvious. Sharpening boosts the details by increasing the contrast of pixels next to one another.

You can select Auto Sharpen under the Enhance menu, but you have no control over the settings of this process so you may not be happy with the results. A better way of sharpening a photo is to use the 'Unsharp Mask' filter. Despite its seemingly contradictory name, this filter reproduces a traditional film technique used to correct the softness often visible in digital photos.

1 Open a photo you wish to sharpen. Click **Enhance** and then **Unsharp Mask...**

TRY THIS
If you need to reduce image noise in your photo, do this before sharpening as the latter can intensify the noise (see pages 50–1).

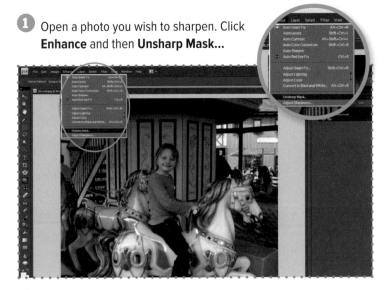

2 On the pop-up window (see opposite), make sure the **Preview** option is checked and set the 'Amount' initially at 100%. The preview window will show how the level of sharpening you apply will affect your photo

3 You can click and drag the preview to show a particular area of your photo. You can zoom into the preview by setting a higher degree of magnification (from 1 to 500%)

Set the sharpening parameters

Under the preview window are three sliders. The sharpening effect on your photo will depend on how you set them.

1 Use the 'Amount' slider to increase the contrast of image pixels. For high-resolution printed images, an amount between 150% and 200% is usually best

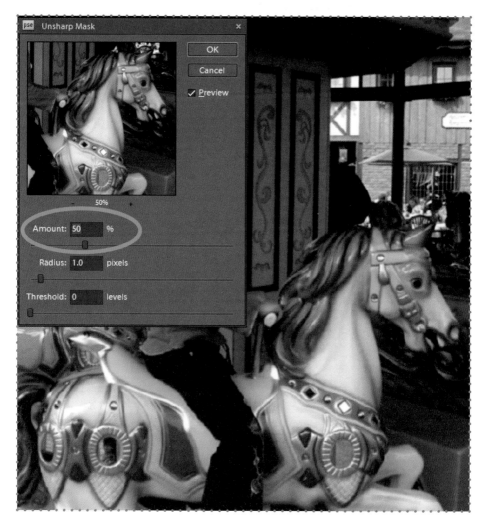

⏵ Fix Common Problems

TRY THIS

If you want to selectively sharpen parts of your photo, click **Enhance** and then **Adjust sharpness...** and select the various options in the option bar, including sharpening strength. Now drag the Sharpening tool over the area you wish to change and click **OK**.

2 Use the 'Radius' slider to determine how many pixels are influenced by the amount of sharpening. A radius between 1 and 2 is usually best. A lower value sharpens only the edge pixels, whereas a higher value sharpens a wider band of pixels

Radius: 1.0 pixels

3 Use the default 'Threshold' value (0) to sharpen all pixels in the image. However, if a photo has a lot of digital noise (distortion), avoid zero as the final photo may look grainy. In this case, try experimenting with values between 2 and 20

4 Experiment with the values to suit your photo and when you have made your adjustments, click **OK**

5 To save your changes, click **File** and then **Save**. If you wish to keep the original photo, click **File** and then **Save As** and give the sharpened version a different name

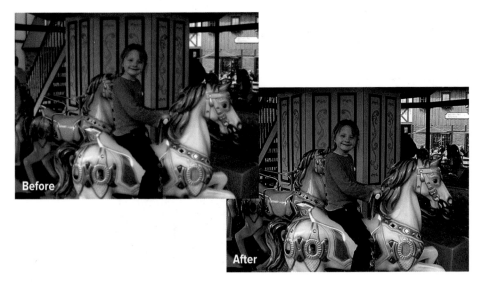

Before

After

REDUCE RED EYE

You've just taken a perfect shot of a family member but the photo seems ruined by the subject's red eyes. This is caused by the illumination of the subject's retina by the camera's flash and it often happens when taking pictures in a darkened room because the subject's iris is wide open. You can remove red eye either automatically or manually.

Remove red eye automatically

When importing or downloading images using the Photo Downloader, Photoshop Elements should search for and remove red eye automatically by default. If it doesn't:

1 Check the setting by clicking **Edit** and then **Preferences**

2 Click **Camera** or **Card Reader** from the left-hand menu, and select **Automatically Fix Red Eyes**

Remove red eye manually

1 Open a photo that is in need of red eye removal

2 From the 'Full Edit' mode, select the **Zoom** tool and left click and drag to make a selection around the eyes. Zoom in to get a close-up view of the eyes

3 Click the **Red Eye Removal** tool from the toolbox – it looks like an eye with crosshairs

4 For a quick fix, click and drag the **Red Eye Removal** tool over the eye to make a selection or click a red area of an eye. Then press **Auto** from the options bar above the photo window. The red area is automatically located and replaced with a neutral grey

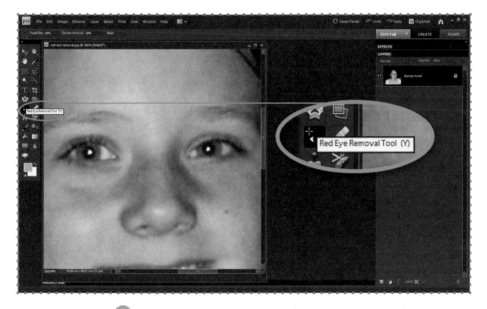

5 You'll need to apply this technique to each eye in turn, but it's a quick and effective option if you have lots of images to correct

6 For more control over how the pupil looks, you can set the 'Pupil Size' from the options bar. Click on the downward-facing arrow next to the percentage figure

7 You can also adjust the darkness of the replacement colour, as the result is often a light-looking grey. From the 'Darken Amount' option drag the slider to the right to change from grey to black

8 Then simply click a red area of an eye or draw a selection over the eye area as before and the red is removed. Repeat for the other eye if necessary

9 To save your changes, click **File** and then **Save**. If you wish to keep the original photo, click **File** and then **Save As** and give the red-eye-free version a different name

▶ Fix Common Problems

BRIGHTEN YOUR PHOTOS

Sometimes a photo that you've taken turns out to be too dark. But a too dark picture can be brightened up using photo-editing software.

Brighten a photo using 'Brightness/Contrast'

1 Open a photo that you would like to work on

2 On the top menu bar click **Enhance** and from the drop-down menu, click **Adjust Lighting** and **Brightness/Contrast**

3 The 'Brightness/Contrast' box will pop up. This has two sliders with arrows that you can scroll to the right or left to add or subtract brightness and contrast. Adjust the 'Brightness' slider first. Try increasing brightness in increments of 10 to start

4 As you increase brightness, you may also need to increase the contrast so your image does not look washed out. Adjust the 'Contrast' slider until you are happy with the result. By ticking and unticking the 'Preview' box you can see the photo before and after your changes

5 Click **File** and then **Save** to save your photo. If you wish to keep the original photo, click **File** and then **Save As** and give the brightened version a different name

Brighten a photo using 'Shadow/Highlights'

On some occasions, you may wish to adjust only certain areas of a photo to bring out more details, say from an area in shadow without the lighter area of your photo becoming too washed out. In this example, the family in the foreground are in deep shadow.

TRY THIS
To reset the photo to how it looked when you opened the box, hold down the **Alt** key and click the **Reset** button.

1 Open a photo that you wish to work on

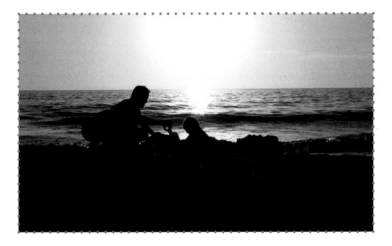

2 On the top menu bar click **Enhance** and from the drop-down menu, click **Adjust Lighting** and **Shadow/Highlights**

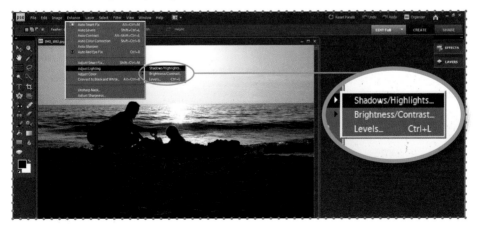

Fix Common Problems

3 The 'Shadows/Highlights' box will pop up. This has three sliders with buttons that you can scroll to the right or left to affect the shadows and highlights on the photograph

4 Drag the slider to the left on 'Lighten Shadows' to brighten the dark areas of your photo and reveal more of the shadow detail

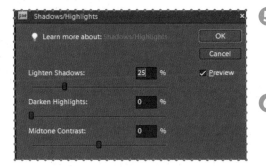

5 Move the slider to the right on 'Darken Highlights' to darken the light areas of your photo and reveal more detail in the highlights

6 Use 'Midtone Contrast' to add to or reduce the contrast of the middle tones. You can use this slider if the image contrast doesn't look right after you've adjusted shadows and highlights

7 Experiment with these sliders until you're happy with the result. By ticking and unticking the 'Preview' box you can see the photo before and after your changes

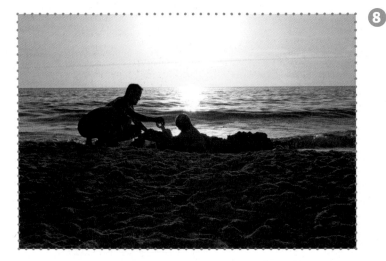

8 Click **File** and then **Save** to save your photo. If you wish to keep the original photo, click **File** and then **Save As** and give the brightened version a different name

ENHANCE PHOTOS

By reading and following all the steps in this chapter, you will get to grips with:

 Changing colours in a photo

 Recomposing photos and removing objects

 Achieving the perfect exposure

▶ Enhance Photos

CHANGE HUE AND SATURATION

Hue is the predominant colour of a part of a photo, while saturation is how intense that colour appears – from white through to a pure colour. Boosting saturation can make colours more vivid, and adjusting the hue can change colours from, say, an orange to a red.

1 Open a photo you wish to transform

2 Click **Layer**, then **New Adjustment Layer** and then **Hue/ Saturation**. Press **OK**

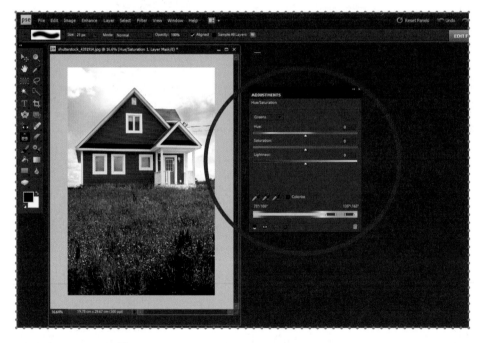

3 In the panel that appears called 'Adjustments' to the right of the photo, choose the colour that you want to change or enhance

4 Using the sliders, you can adjust how vivid that band of colours (such as reds) appears in the photo using the 'Saturation' slider. In this case, the green of the grass has been made more vivid by moving the slider to the right

5 Click on the **Master** pop-up menu, choose a colour and use the 'Saturation' slider to enhance that colour and add more punch to an image

6 Adjust the 'Hue' and 'Lightness' sliders to suit

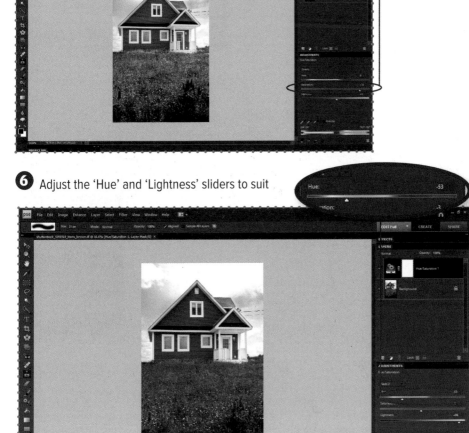

⊚ Enhance Photos

TIP

There are lots of preset adjustments to choose from divided into categories that include 'Black and White', 'Color', 'Lighting' and 'Special Effects'. They range from practical to fun so take some time to experiment.

CHANGE COLOUR USING SMART BRUSH

With the Smart Brush tool it's easy to make tonal and colour changes to specific areas of a photo. It works in one step to both select an area and apply a preset adjustment. As it automatically creates an adjustment layer, you can try different effects, as the original photo remains unchanged on its own separate layer.

1 Open a photo you wish to transform, then click the **Smart Brush** tool from the toolbar

2 The 'Smart Brush' adjustment menu opens showing the adjustment presets listed in categories. If it doesn't open automatically, click the down arrow to the right of the 'Smart Adjustment' preset box in the options bar

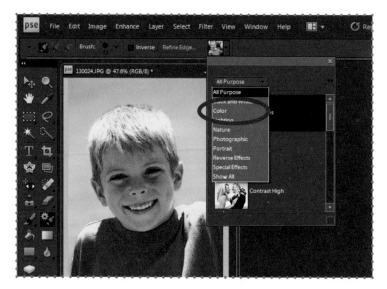

3 In this example, a colour change is being made, so click the down arrow next to 'All Purpose' and select **Color**

4 Now select a colour option. In this example, the colour of the boy's jumper is going to be changed to green, so select 'Going Green'. Click anywhere in the grey area of the option bar to close the adjustment menu

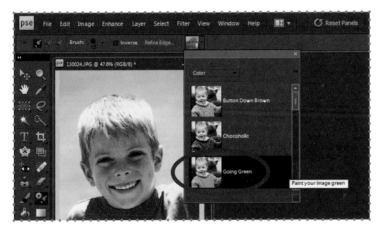

5 You can change the size of the Smart Brush tool by clicking the down arrow to the right of the brush in the options bar and adjusting the settings

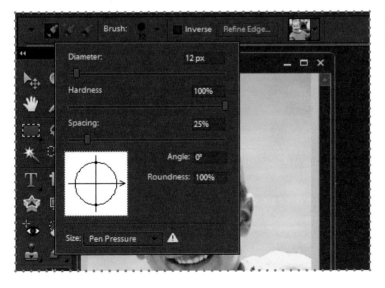

TRY THIS
Some of the tools in the 'EDIT Quick' workspace use the Smart Brush tool technology. Go to **EDIT Quick** (see page 37) to open the 'Quick Fix' workspace. Here you can use the red-eye removal, whiten teeth, blue skies and black and white high contrast tools with the Smart Brush tool. However, they apply their changes automatically with one click, so you can't tweak the effect.

enhance photos

6 Using the brush paint the area of photo you wish to change – in this case the boy's jumper. The Smart Brush tool selects the jumper and applies the colour change. A colour pin will appear where you first applied the brush tool

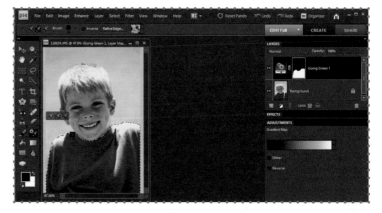

7 If, when painting over the area, the Smart Brush selects either too much or too little of the area you want to change, you can fine-tune the selection:

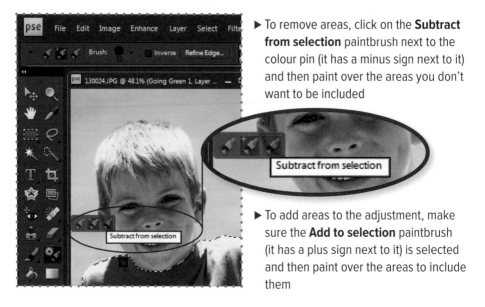

▶ To remove areas, click on the **Subtract from selection** paintbrush next to the colour pin (it has a minus sign next to it) and then paint over the areas you don't want to be included

▶ To add areas to the adjustment, make sure the **Add to selection** paintbrush (it has a plus sign next to it) is selected and then paint over the areas to include them

8 To smooth the selection's edges, click **Refine Edges...** in the options bar, adjust the settings in the dialog box and then click **OK**

9 As the Smart Brush tool works by creating a new adjustment layer complete with a layer mask, it's easy to change the colour of the adjustment. Making sure you have the adjustment layer selected, open the 'Smart Brush' adjustment menu in the options bar and choose a different colour preset, such as 'Grape Expectations'. The colour of the selection – in this case the jumper – will change

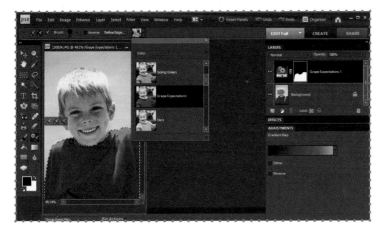

Make adjustments to another area of the image

To change another area of the same photo, first click the **Background** layer to select it. Then select the **Smart Brush** tool and follow the steps of this tutorial again. You can make as many changes as you like, with each one remaining editable on their own adjustment layer. A new colour pin appears for each adjustment preset, making it easier to tweak each one individually. This is particularly useful when working with lots of adjustments.

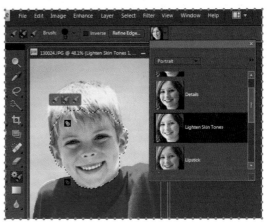

⏵ Enhance Photos

REMOVE UNWANTED ELEMENTS

If you need to fix larger areas of your digital photo, then the Clone Stamp is the tool to use. This allows you to copy one area of an image onto another area. You can use it to remove imperfections in your photo, paint over distracting objects or even duplicate objects.

Find the Clone Stamp tool

1 Open a photo you wish to transform

2 If necessary, zoom into the area you wish to retouch as this will allow for more accuracy. In this photo, for example, we're going to remove a tree from the cliff top

3 From the toolbar on the left, click the **Clone Stamp** tool

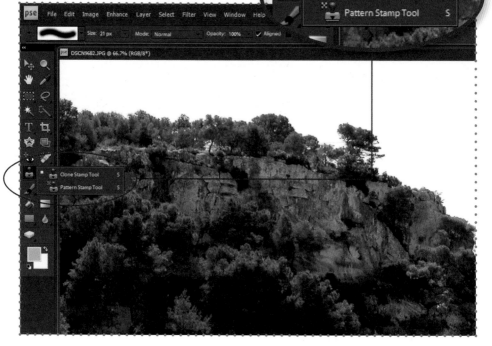

Use the Clone Stamp options bar

The Clone Stamp options bar appears at the top of your screen under the main menu. The default settings are fine to use in most cases although you may want to change your brush size for more accurate retouching. However, in the options bar you can set various items.

1 To change the brush shape, click the arrow next to the brush sample and choose a brush category from the pop-up menu. Then select a brush thumbnail

2 Select a brush size that's smaller than the area to be retouched

3 Click **Mode** to change how the sampled pixels blend with existing pixels. 'Normal' mode lays new pixels over the original pixels

4 A low opacity will let the image under a paint stroke show through. To replace the original image with the copied selection leave the opacity at 100%

5 When the 'Aligned' box is checked you can move the sampled area with the cursor as you begin to paint. This is useful when you want to get rid of unwanted areas

6 'Sample All Layers' lets you copy from all visible layers if you're working with layers (see pages 28–30)

▶ Enhance Photos

Clone Stamping in action

1 Place the brush (the black circle) on the photo where you want to sample. In the example here, a sample of the sky has been used to remove the tree

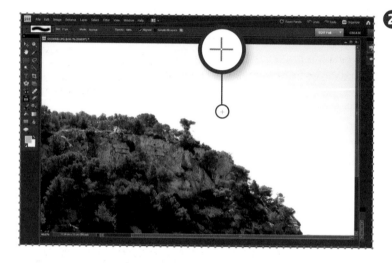

2 Hold down the **Alt** key (the cursor will change into a bullseye) and click. The Clone Stamp tool will duplicate the pixels at this sample point in your photo as you paint

3 Click the **Clone Stamp** tool brush on the area of the photograph that you want to retouch and paint out the unwanted area. Your sampled area will be marked with a cross. The pixels from the sampled area will appear on top of your original photo

4 When you're happy with the result, click **File** and then **Save** to save your photo. If you want to keep the original photo, click **File** and **Save As** and give the retouched version of your photo a new name

RECOMPOSE PHOTOS

A powerful tool in Photoshop Elements is the Recompose tool. This lets you resize photos without distorting important content such as people, animals and buildings. Normally when you scale a photo all the pixels in the photo are affected, but the Recompose tool intelligently alters only the pixels in unimportant areas of the photo.

It's a great tool for improving a poor photo composition – say a group of three or four people with one person positioned a little too far away from the others – or for changing the orientation of a photo from landscape to portrait.

TIP

You can view the 'Help' dialog box at any time while working with the Recompose tool by right-clicking the photo and selecting **Show Recompose Help**.

enhance photos

Recompose a photo

1 Open the files you wish to recompose

2 In the 'Layers' panel, double-click the **Background** layer. In the 'New Layer' dialog box that appears, click **OK**. This unlocks the 'Background' layer so you can make changes to it

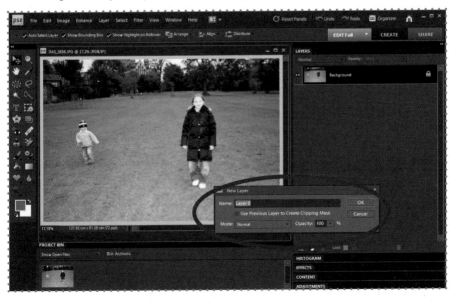

3 Click **Image**, then **Recompose**

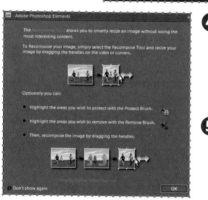

4 A dialog box opens explaining how the Recompose tool works. You can view a demo of the tool by clicking **View An Online Video Tutorial**. If you don't want to view this dialog again, select **Don't show again**

5 Drag the right-hand handle of the image to recompose your photo. In this case, the figure of the girl moves closer to the boy without being distorted

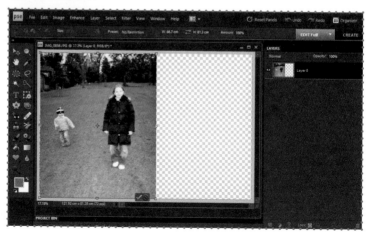

6 To change the orientation of the photo to portrait, click-and-drag the left-hand handle

7 You can choose to recompose your photo to a specific print size. In the options bar, click the **Preset** drop-down menu and choose a size, for example '5 x 7'. The photo will automatically be resized and rescaled to the selected size

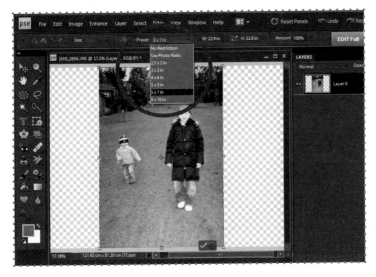

8 When you're happy with the size and composition, click the green **Commit** (tick) icon to apply the change

Advanced control

The Recompose tool automatically preserves parts of a photo that it considers are important. Unimportant areas such as the background are deleted. However, to achieve the perfect composition, you may need more control over which areas of a photo are kept. The Recompose tool lets you define areas of a photo to keep or remove.

1 With your photo open and the **Recompose** tool selected, click the green **Protect** brush in the options bar

 Use this to draw over the parts of the photo that you wish to keep. These areas will be marked green. You don't have to be too precise when marking as Elements will recognise the areas to be protected

 To mark areas of a photo that you wish to be removed, click the red **Remove** brush tool from the options bar and use this to draw over the areas. They will be marked red

4 If you highlight too much – either when using the green 'Protect' or red 'Remove' brushes – you can click on the relevant **Eraser** tool and use this to clean up the marked-up areas on your photo

5 Now recompose your photo by clicking and dragging the right-hand sizing handle. As you drag, you'll see the areas marked for removal disappear while the important areas of the photo are preserved

6 When you're happy with the results of the Recompose tool, click the green **Commit** icon

USE PHOTOMERGE FOR THE PERFECT EXPOSURE

The Photomerge Exposure feature lets you blend two or more photos together to get one perfectly exposed photo – which your digital camera may not have been able to capture in one shot. For example, you may have a family photo taken at night where the flash has illuminated everyone's faces but left the background in almost total darkness. You may have a nearly identical shot taken without the flash where the family are silhouettes against a bright background. You can use Photomerge Exposure to blend these photos, and create a perfectly exposed photo.

TRY THIS

The Photomerge family of features can be found by clicking **File**, then **New**. There are five features that let you combine several photos to create one new image.

There are two ways to use the Photomerge Exposure – either automatic or manual mode:

▶ Automatic mode gives the best result with photos shot at different exposure value using the digital camera's Exposure Bracketing feature (see page 78).
▶ Manual mode works best with a couple of photos that have been taken with the flash turned on and turned off (see pages 76–7).

Flash off Flash on

You don't have to decide which mode to use. When you select Photomerge Exposure, Photoshop Elements analyses the images you've selected and automatically chooses the best mode.

enhance photos

Use manual Photomerge Exposure

1 Open the files you wish to merge

2 The files should automatically appear in the project bin at the bottom of the image window. If not, select **Show Open Files** in the project bin to view all the opened files

3 From the project bin select the photos to use, by holding down the **Shift** key and clicking each one in turn. You can choose between a minimum of two and a maximum of ten photos

4 Select **File**, then **New** and then **Photomerge Exposure....** Photoshop Elements will look at the selected photos and select the appropriate mode – which in this case is Manual

5 The first image in the project bin is displayed as the foreground photo. Here, there is a shot where the camera has correctly exposed the shot for flash illumination of the subject in the foreground but this has meant that all the detail in the background has been lost in darkness

6 Select an image as the background photo by clicking and dragging it from the project bin to the background position

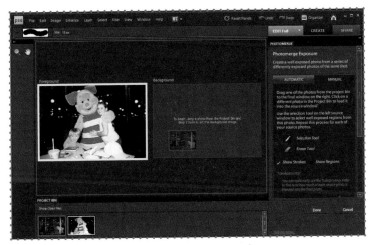

7 Now you need to indicate the part of the foreground image that you wish to combine with the background image. From the right-hand panel click the **Selection** tool and draw a line in the part of the foreground photo that you wish to combine with the background. You don't need to cover the entire area – Photoshop will recognise the part of the image to use. The selected area will now appear in the background photo

8 You may find you have dark areas around the subject when it has been combined with the background. If so, click on the background image in the project bin to bring it into the foreground position. From the right-hand panel click the **Selection** tool and draw over the areas you want brought into the combined image

9 Click **Done** to apply the Photomerge Exposure changes

TRY THIS

You can further fine-tune the Photomerge Exposure before Step 9 using the options available in the right-hand panel including 'Edge Blending', which smoothes the hard edges of the selection.

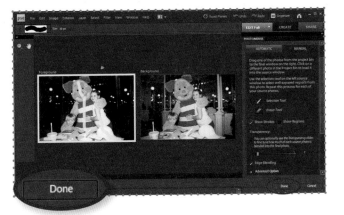

⏵ Enhance Photos

TRY THIS

Having applied the automatic Photomerge Exposure, you can click on an image in the project bin to eliminate it from the combined mix that's the final effect. This lets you experiment with different combinations to find the perfect result.

Use automatic Photomerge Exposure

This works best when you use photos that are the results of exposure bracketing – for example you may have an underexposed shot and an overexposed shot.

1 Open the files you wish to merge

2 The files should automatically appear in the project bin at the bottom of the image window

3 Hold down the **Shift** key and click to select the images in the project bin. You can select a minimum of two and a maximum of ten photos to use

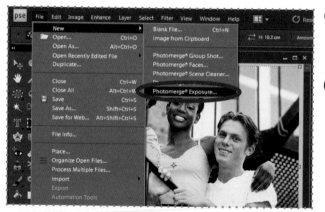

4 Select **File**, then **New** and then **Photomerge Exposure**

5 Photoshop Elements will analyse the photos and, in this case, apply the 'Automatic' function. The result will appear in the image window

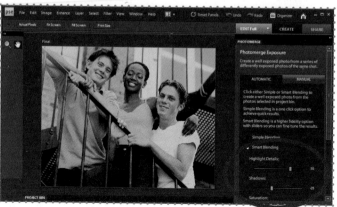

6 If necessary, use the sliders in the right-hand panel to adjust the image. For example, drag the 'Shadow' slider to the left to make shadow areas darker

PERFECT FAMILY SHOTS

By reading and following all the steps in this chapter, you will get to grips with:

 Merging several photos for the perfect group shot

 Removing wrinkles and blemishes

 Brightening eyes and whitening teeth

Perfect Family Shots

TIP
Photomerge Group Shot works best when head and body positions in photos are similar.

USE PHOTOMERGE GROUP SHOT

You know how it goes – you're trying to take the perfect family photo only to find that someone in the group is looking the wrong way, not smiling or, as often with children, pulling a face or sticking their tongue out. And no matter how many shots you snap with your camera, you can never get everyone looking just right. Using Photoshop Elements 8's Photomerge Group Shot you can create the perfect group photo from multiple images.

 Open the photos you wish to merge

 Here two shots have been chosen, but you can open up to ten photos

BE CAREFUL
Photomerge Group Shot uses auto alignment, which works well in most instances. Use the Alignment tool only if the automatic alignment didn't produce the expected result.

❸ The files should automatically appear in the project bin at the bottom of the image window

❹ Choose **File**, then **New** and then **Photomerge Group Shot**

❺ From the dialog window that appears click **Open All**

6 Click the photo that you wish to use as the final base image – usually the one in which most people appear as you'd like – and drag it from the project bin to the 'Final' window

7 Click the other photos in the project bin in turn to fill the 'Source' window. Photos are colour coded to help you keep track of which one you're working on. Select the **Pencil** tool from the right panel and use it to mark the areas in the 'Source' photo that you want to appear into the final photo. In this case, the boy's face has been drawn over. If you mark up too much, use the **Eraser** tool to remove content

8 You'll immediately see the results in the 'Final' window. You can fine-tune the results using the options in the right-hand panel

9 When you're happy with the results, click **Done**. You'll see a new image appear in the project bin – the result of Photomerge Group Shot

⊳ Perfect Family Shots

FIX BLEMISHES AND SPOTS

It's rare to take a perfect photo and when you view your photo you may see one or more imperfections. Flaws can range from major ones such as unwanted telegraph poles spoiling a countryside scene to portraits of family members spoilt by skin blemishes. An advantage of digital photography is that you can quickly fix minor flaws in your photo by retouching.

Use the Spot Healing Brush

The Spot Healing Brush is best for removing smaller defects such as spots. You sample part of a photograph, then blend that sample with another part of the photograph. Here's how:

1 Open the photo you wish to work on

2 Click on the **Zoom** tool on the toolbar, or on the top menu click **View** and then **Zoom in**. Zoom in on the area of the photo you wish to retouch

TIP

While it's tempting to use retouching tools to make someone look years younger or have flawless skin, it's best not to overdo it. You don't want to change a photo so much that that person ceases to resemble themselves.

③ Click the **Spot Healing Brush** tool. It looks like a plaster, with a dotted area in the left corner of the icon

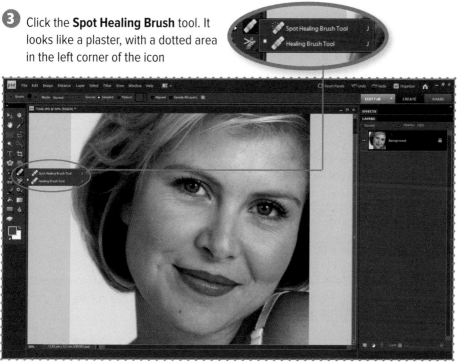

④ Choose a brush size. A brush that is slightly larger than the area you want to fix works best so that you can cover the entire area with one click

⑤ Choose a **Type** option in the options bar. There are two choices:

- ▶ **Proximity Match** is normally set as the default and works best for most skin retouching situations
- ▶ **Create Texture** brush type, which is more suited to areas that have a texture

 Place the brush (the black circle) directly over the blemish. The brush appears as a circle or shape

7 Click and you'll see the spot disappear. The tool fills in the damaged area of the screen based on nearby sections of the image

TRY THIS

Brushes come in all shapes and sizes, though for most editing tasks you will need to use either a hard-round and soft-round brush. Soft-round brushes have a feathered edge that looks slightly out of focus.

8 You may see a faint white smear on the area where the blemish previously was. If so, click the brush on the same area again

9 Click **File** and then **Save** to save your retouched photo

REDUCE WRINKLES

Using Elements' Healing Brush you can take years off a person's age by removing wrinkles. While similar to the Spot Healing Brush used on pages 82–4, the Healing Brush works by sampling selected pixels in the photo (or even another photo) and then applying these pixels to the area you wish to 'heal'. It also matches the lighting, shading, texture and transparency of the sampled pixels to the pixels being healed, helping to keep the result natural looking.

The trick to successful photo retouching is to make subtle changes, otherwise, like bad plastic surgery, you may end up with a picture that barely resembles the person you know. It's therefore best to do retouching work on a duplicate layer of the original photo. Then, when you finish retouching, you can blend the two layers. This technique also helps makes retouching work look more realistic.

1 Open the file you wish to work on

2 Right-click the **Background** layer in the 'Layers' panel. In the pop-up menu, choose **Duplicate Layer...**

3 In the 'Duplicate Layer' box that appears on screen give your new layer a name and click **OK**

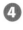 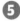
4 Using the **Zoom** tool, enlarge the area of the photo that you want to work on – in this case the wrinkles around the eyes

5 Click on the **Healing Brush** from the toolbar. It may be nested under the Spot Healing Brush. If so, click on the tiny triangle next to this tool and you'll see the Healing Brush

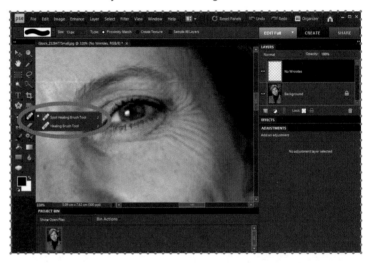

6 On the options bar, click on **Brush** to open the 'Brush Picker' and set the brush diameter to a suitable size – make sure it's big enough to cover wrinkle lines – here a 9-pixel brush has been

chosen. Close the panel and select the **Aligned** check box in the options bar. Leave the other settings at their defaults (**Normal** selected as the 'Mode' option and **Sampled** selected for 'Source')

7 Hold down the **Alt** key and click once on an area of the face that's free of wrinkles. Try to sample a smooth area as close to the wrinkle as possible

8 With the **Healing Brush** paint over the wrinkles. The wrinkles will disappear, yet the texture and detail of the skin remains intact

9 Now the wrinkles are removed, it's worth bringing a little of them back to ensure the result looks natural. In the 'Layers' panel, use the slider to reduce the opacity of the layer to allow a small amount of the original image to show through. The ideal result is to make the wrinkles less prominent

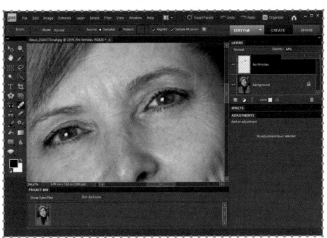

▶ Perfect Family Shots

—

TRY THIS

If you feel you've gone too far with brightening the teeth, use the 'Opacity' slider to reduce the transparency of the adjustment layer. Reducing the opacity will allow more of the original teeth colouring to show through, resulting in a more realistic effect.

TEETH WHITENING MADE EASY

Sometimes a great portrait shot is let down by the smiling subject's teeth. But with Element's selection tools and clever adjustment options, you can quickly transform a person's yellow or grey teeth into pearly whites worthy of a Hollywood film star.

Prepare the photograph

 Open the photo you wish to work on

2 Right-click the **Background** layer in the 'Layers' panel. In the pop-up menu, choose **Duplicate Layer...**, then click **OK** in the 'Duplicate Layer' box that appears on screen. This will create a 'Background copy' layer

3 Use the **Zoom** tool to enlarge the photo so the teeth are in close-up. This will help you to make an accurate selection

Select the teeth

 Click the **Quick Selection** tool

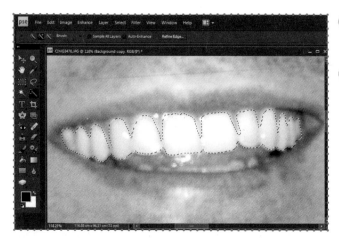

2 Click, hold and drag on the teeth

3 If you select an area of the gum by mistake, press and hold the Alt key to change the brush to a minus brush. Place the brush outside the selection, click, hold and drag

88

4 It's a good idea to feather the selection so the changes you make blend well into the adjacent areas. Click **Select**, then **Feather** and set the 'Feather radius' to 2 pixels

Make the adjustment

1 Click **Layer**, then **New Adjustment Layer** and then **Hue/ Saturation...** to create a new adjustment layer

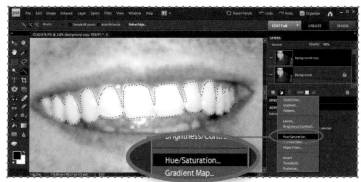

2 Usually when teeth need whitening it's because they're yellowish in colour. So, in the 'Hue/Saturation' dialog box, click on **Master** and from the drop-down menu select **Yellows**

3 Move the 'Saturation' slide to the left to decrease the saturation. How much will depend on the photo but try -50 as a starting point

4 Move the 'Lightness' slider to the right to brighten the teeth

5 Be careful not to over whiten the teeth otherwise the effect will be unrealistic. Switch between the before and after image by clicking on the eye icon next to the adjustment layer in the 'Layers' panel

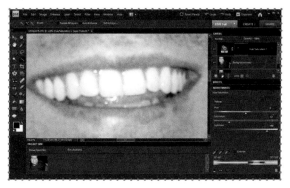

6 Click **File**, then **Save** to save your photo

Perfect Family Shots

TIP

If the eyes are evenly lighted, you can correct all four white areas at once but it's usually a good idea to work on one eye at a time. This way you can compare eyes side by side as you work, which helps avoid excessive whitening.

MAKE EYES BRIGHTER

The eyes are one of the first things we notice in a portrait photo but sometimes the whites of the eye look grey and dull. Use Photoshop Elements to lighten these areas to give those in your portrait shots a bright-eyed look.

1 Open the photo you wish to work on

2 Right-click the **Background** layer in the 'Layers' panel. In the pop-up menu, choose **Duplicate Layer...**, then click **OK** in the 'Duplicate Layer' box that appears on screen. This creates a 'Background copy' layer

3 Use the **Zoom** tool to view both eyes in close-up

4 Click the **Quick Selection** tool and in the right eye draw a selection around the white area to the left of the pupil. Repeat for the white area to the right of the pupil

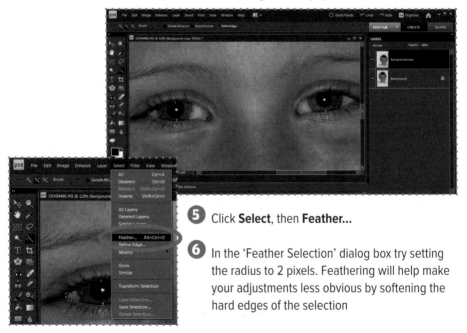

5 Click **Select**, then **Feather...**

6 In the 'Feather Selection' dialog box try setting the radius to 2 pixels. Feathering will help make your adjustments less obvious by softening the hard edges of the selection

7 Click **Layer**, then **New Adjustment Layer** and then **Hue/ Saturation...** to create a new adjustment layer

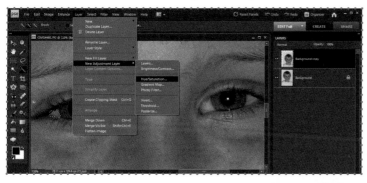

8 In the 'Adjustments' panel, click on the down arrow next to Master, select **Reds** and decrease the saturation to say -50. If the eyes' whites look yellow, select **Yellows** from the drop-down menu and reduce the saturation by a similar amount.

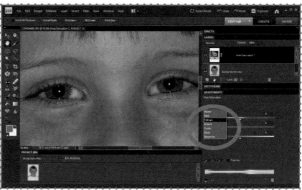

If needed, move the 'Lightness' slider to the right to whiten the eyes further but remember to keep it subtle and realistic

9 When finished, hold down the **Shift** key and in the 'Layers' panel select both the 'Background copy' layer and the 'Hue/Saturation' layer. Click **Layer**, then **Merge Down**. You can now save the photo

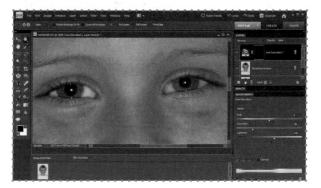

⏵ Perfect Family Shots

TRY THIS

While it's essential to zoom in when repairing a photo, it's good to check changes at normal size as you work. To make this easier, you can open a duplicate of the photo at 100% view. To do this, click **View**, then **New Window for...**. Use the **Move** tool to drag the duplicate photo so you can see both views. The changes you make in the enlarged photo will be reflected in the smaller view.

REMOVE GLARE FROM GLASSES

One annoying thing that can ruin a portrait shot is the glare that appears on the glasses of the person you've photographed. You probably didn't notice it when taking the photo but when viewed later the glare or reflection is usually obvious and distracting.

You can remove glare and reflections in Elements using either the Healing Brush or the Clone Stamp tools. Both work by replacing pixels in an area with those from another selected area. The key difference between them is that the Healing Brush blends in some texture from the original area whereas the Clone Stamp tool completely covers up the original area with new pixels from a different part of the photo.

Use the Brush Picker tool

1 Open the file you want to work on

2 Right-click the **Background** layer in the 'Layers' panel. In the pop-up menu, choose **Duplicate Layer...**

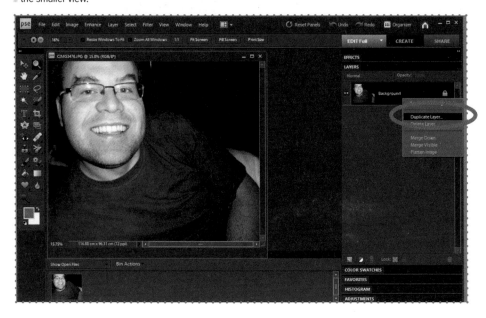

3 Click **OK** in the 'Duplicate Layer' box that appears on screen. A 'Background copy' layer will be created. By making your changes on this separate layer, the original will be left intact

pse Duplicate Layer	×
Duplicate: Background	OK
As: Background copy	Cancel
Destination	
Document: CIMG3476.JPG ▼	
Name:	

4 Use the **Zoom** tool to zoom into the right eye

5 Click the **Healing Brush** from the toolbar

Healing Brush Tool (J)

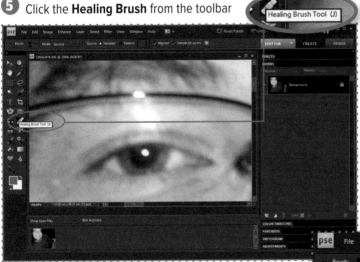

TIP
You can change the size of your brush as you work by pressing the left and right bracket keys until it's the size you want it.

6 In the options bar click on the arrow next to Brush to open the **Brush Picker** and use the slider to adjust the size of the brush. To remove the glare from the rim of the glasses, it's best to work with a small brush

7 Make sure the 'Hardness' slider is all the way to the left or 0%. Continuing left to right in the options bar choose **Normal**, **Sampled**, tick **Aligned** and **Sample All Layers**

Perfect Family Shots

TRY THIS

When using either the Clone Stamp or Healing Brush tools, it is best to work slowly, sampling from different areas to avoid repeat patterns and adjust your brush size as needed. In that way, the end result will look natural.

8 Hold down the **Alt** key to sample an area of your photo where there's no glare, but one that's similar to what you want to replace the glare with. In this case, choose somewhere on the black rim of the glasses to the right of the glare. Your cursor will turn into a bullseye while you're sampling

9 Let go of the Alt key and move your cursor over the glare. Now just click and drag with your cursor to blend the area with the sampled pixels

Use the Clone Stamp tool

1 For the glare on the glass, click the **Clone Stamp** tool from the toolbar

2 In the options bar click on the arrow next to the brush mark to open the **Brush Picker**. This time choose a soft round brush. Use the down arrow after the word **Size** and use the slider to adjust the size of the brush. Move the 'Hardness' slider to the left or 0%

Clone Stamp Tool (S)

3 Continuing left to right in the options bar choose **Normal**,
Opacity at 100%, check **Aligned** and **Sample All Layers**

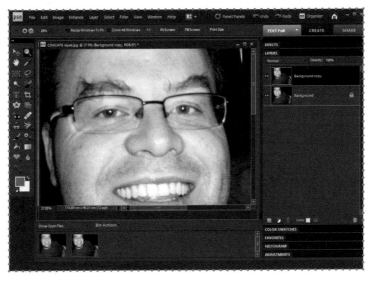

4 Hold down the **Alt** key to sample an area of the eyelid without
glare. Your cursor will again turn into a bullseye while you're
sampling

5 Let go of the Alt key and move your cursor over the glare.
Click-and-drag with your cursor to paint over the glare with the
sampled pixels

6 Repeat the process for the other eye. Remember to zoom out to
view your
photo at
100% view
so you can
judge how
successful
the changes
are

7 When
finished,
click **File**,
then **Save**
to save
your edited
photo

ADJUST SKIN TONE

Skin tone in photos can make people look less healthy than they actually are, especially if the colours in the image are washed out.

 Open a photo you wish to transform

 Click **Enhance**, then **Adjust Color** and then **Adjust Color For Skin Tone**

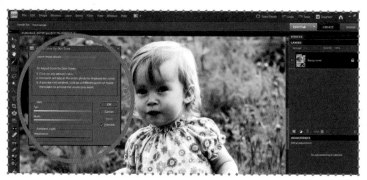

③ Click an area of skin, and the skin tone is automatically improved

④ Optionally, drag the sliders to fine-tune the correction:
- ▶ **Tan** increases or decreases the level of brown in skin tones
- ▶ **Blush** increases or decreases the level of red in skin tones
- ▶ **Temperature** changes the overall colour of skin tones

⑤ Once done, click **OK**

Before

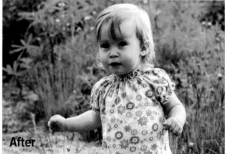

After

GET CREATIVE

By reading and following all the steps in this chapter, you will get to grips with:

 Creating black and white photos and panoramas

 Restoring old photos and adding special effects

 Transforming photos into art

▶ Get Creative

CREATE BLACK AND WHITE PHOTOS

Converting a colour photo to black and white can make a dramatic effect. The simplicity of black and white helps create atmosphere, highlight detail and adds a look of classic elegance to your photos. Regardless of the subject, this technique produces impressive results.

Most compact digital cameras can take black and white photos, with excellent results. But, ultimately, this will limit your options, as you can't then convert to colour if you change your mind at a later date.

This image of a sleeping mother and child has been chosen because of its strong composition, but converting to black and white gives it a classic elegance. You may want to choose a highly coloured image while you're experimenting with the steps explained here. It makes any slight changes you make on screen more visible and easier to interpret.

1 Open the photo you wish to change to black and white

2 From the top menu click **Enhance**, then click on **Convert to Black and White**

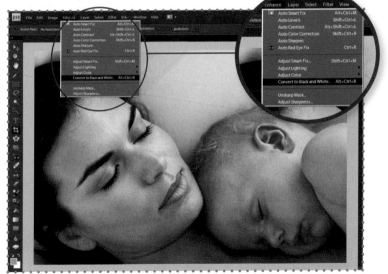

3 This will bring up the 'Convert to Black and White' box. As well as providing crucial 'Before' and 'After' views, the 'Convert to Black and White' window offers six presets or styles:

▶ Infrared Effect
▶ Newspaper
▶ Portraits
▶ Scenic Landscape
▶ Urban/Snapshots
▶ Vivid Landscapes

Clicking on one of these automatically adjusts the intensity of the red, green and blue (RGB) channels, to give a certain look to the new black and white photo. In this example, Portraits has been chosen

4 You can also experiment with the sliders to change or boost the black and white effect. In this example, the contrast has been boosted slightly by dragging the slider to the right

 Get Creative

⑤ When finished with your selection, click **OK** to transform your photo into black and white

⑥ Click **File** and then **Save** to save your photo. If you want to keep the original photo, click **File** and **Save As** and give the black and white version of your photo a new name

WORK WITH FILTERS

One of the great advantages of Photoshop Elements is that it offers everyone the chance to be an artist. Even if your drawing skills are limited to stick figures, you can use Photoshop Elements to transform an existing photo into a pencil sketch, a cartoon, a watercolour or many other types of drawings. This is achieved by applying a filter to an image.

Photoshop Elements comes with a whole host of filters. Along with art effects filters, there are filters for cleaning or retouching photos, as well as transforming photos with distortion effects.

Filter categories

The filters are divided into categories, each of which may contain several filters. Categories include the ones described overleaf.

TRY THIS
In addition to the filters provided by Adobe, some filters by third-party developers are available as plug-ins. Once installed, these plug-in filters appear at the bottom of the 'Filter' list.

get creative

⏵ Get Creative

Correct Camera Distortion... Fix common camera lens problems such as vignetting. Also rotate an image and fix image perspective caused by vertical or horizontal camera tilt.

Adjustments Alter a photo's brightness, colour and tone, and convert into black and white.

Artistic Apply a simulation of traditional art such as watercolour or charcoal.

TRY THIS
You can apply a filter using the 'Filter' menu. Click **Filter**, then choose a submenu followed by the filter you want to apply. If the filter name is followed by ellipses (...), a 'Filter Options' dialog box appears. Here you can enter values or select options.

Blur Useful for retouching photos, these soften a photo or a selection.

Brush Strokes Different brush and ink stroke effects that create a painterly look.

Distort Geometrically distort an image, creating three-dimensional and other reshaping effects.

Noise Useful for retouching photos, these remove problem areas, such as dust and scratches or help blend a selection into the surrounding pixels.

Pixelate Sharpen a photo or selection.

Render Create cloud patterns, lens flare and lightning effects.

Sketch Add texture either for depth or a hand-drawn look.

Stylize Produce a painted or impressionistic effect.

Texture Give the appearance of depth or add an organic look.

Filter Gallery

There are several ways to select and apply a filter in Photoshop Elements, but the easiest way is to use the 'Filter Gallery' (as shown below). Here you can apply filters cumulatively, and apply individual filters more than once. You can also rearrange filters and change the filter settings to get the exact look you want.

Not all of Element's filters are available from the 'Filter Gallery'. Some are available only as individual commands from the 'Filter' menu – see TRY THIS, opposite.

PREVIEW WINDOW

THUMBNAIL OF FILTER

SHOW/ HIDE EFFECT LAYER

FILTER SETTINGS

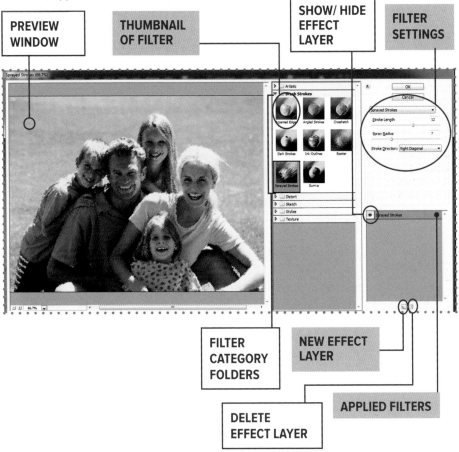

FILTER CATEGORY FOLDERS

NEW EFFECT LAYER

APPLIED FILTERS

DELETE EFFECT LAYER

Get Creative

TRY THIS
Each filter you apply is displayed in the lower-right area of the 'Filter Gallery' dialog box. To delete a filter, select it and click the **Delete effect layer** button.

Apply a filter

With a photo open in the 'EDIT Full' workspace, you can apply a filter in the following steps:

1 Choose where to apply the filter. To apply a filter to an entire layer, select the layer in the 'Layers' panel by clicking on it. Alternatively, to apply a filter to just part of a photo, use one of the selection tools to select an area (see pages 22–3)

2 Click **Filter**, then **Filter Gallery...**

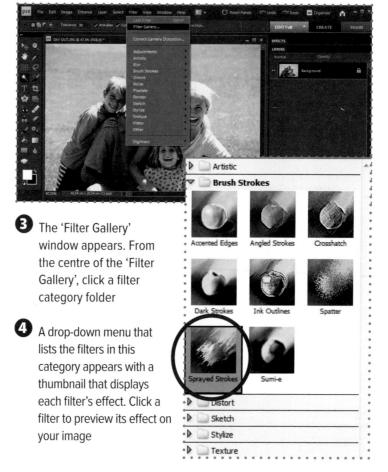

3 The 'Filter Gallery' window appears. From the centre of the 'Filter Gallery', click a filter category folder

TRY THIS
To edit a filter's settings, select it from the list and make any changes. To rearrange the order of the applied filters, click and drag them into position, but be aware that doing this will change the overall effect.

4 A drop-down menu that lists the filters in this category appears with a thumbnail that displays each filter's effect. Click a filter to preview its effect on your image

5 Use the sliders and options in the right-hand panel to adjust the filter settings

6 When you're happy with the results, click **OK** to apply the filter and the editing window closes

7 To apply another filter, go back into the 'Filter Gallery' and click the **New effect layer** button at the bottom of the editing window. This duplicates the existing filter

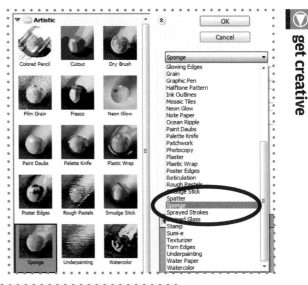

8 Select a new filter. This will replace the duplicate in the 'Applied Filters' area of the 'Filter Gallery' window

9 When you've finished, click **OK** to apply the filters

CREATE AN ARTISTIC EFFECT

There are lots of other filters that can can be used to transform your photo into a piece of artwork. Here's how to turn your picture into a drawing.

 Open a photo you wish to transform

❷ With the photo open in the main window, click **Filter** then **Artistic** and from the drop-down menu choose an effect you'd like to apply to your photo. In this example **Colored Pencil** has been chosen

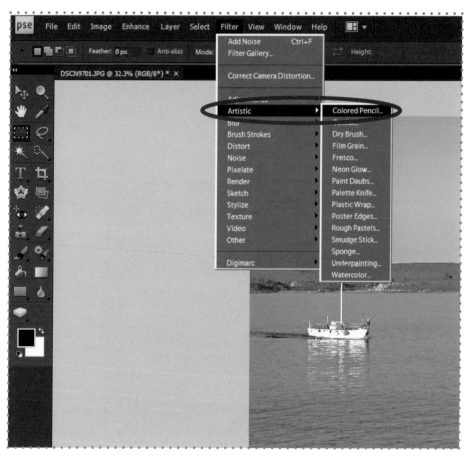

3 Your photo will be previewed in the 'Artistic' filter menu window with the **Colored Pencil** filter applied. Click on the image sizing box at the bottom left of the window (here it's set at 50%) and click on **Fit in View** so you can see all of the image

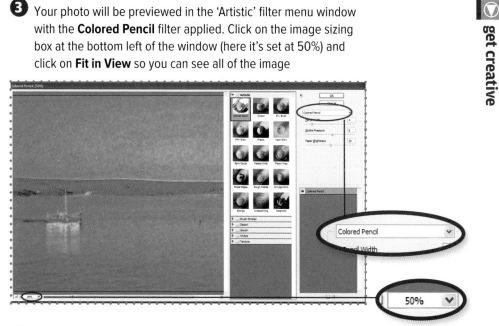

4 Switch between 'Artistic' filters on the right-hand side of the window by clicking on the name of the current filter (in this instance **Colored Pencil**). Choose other effects from the drop-down menu

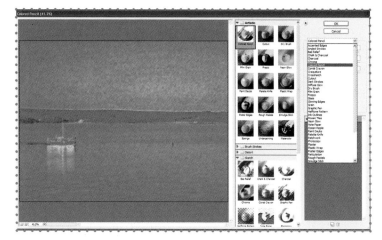

5 Beneath this drop-down menu are a number of sliders, which vary depending on the type of artistic filter you're applying. In this case, there are three: 'Pencil Width', 'Stroke Pressure' and 'Paper Brightness'. Experiment with the sliders until you're happy with the result

6 Click **OK** to apply the effect to your photo and you will automatically be taken back to the image window

7 Save the effect by clicking **File** then **Save**. To keep the original photo, click **File** and then **Save As** and give the artistic version of your photo a new name

ADD TEXT TO PHOTOS

With Photoshop Elements it is possible to add text onto the photo before printing – a great way to jazz them up and add a special message to family and friends.

1 Open a photo you wish to add text to

2 Choose the **Horizontal Type** tool, which looks like the letter 'T', and click on the image where you'd like the text for the message to begin. You will see a new layer open to the right of the photo. Start typing your message on the photo

3 You can change the font and size of the text in the options bar above the photo. With the type selected, use the colour menu to change the colour of the text

4 To move the text, click on the **Move** tool, then click on the text and, holding the mouse button down, drag and position it where you want on the image

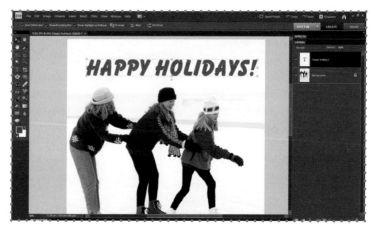

5 Drop shadows can help text stand out from the background. To add a drop shadow, click the **Move** tool to select the text. Click **Layer**, then **Layer Style** and then **Style Settings**. Ensure that 'Preview' is ticked, and tick 'Drop Shadow'. Adjust the settings to add a drop shadow to the text

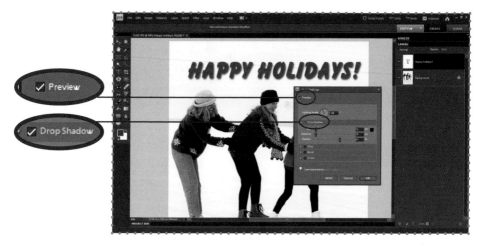

6 Text doesn't have to run in a straight line. To warp text, select the text using the **Horizontal Type** tool, and click the **Warp Text** icon in the options bar. Choose a style, such as **Arc**, from the pop-up menu and adjust the settings to suit

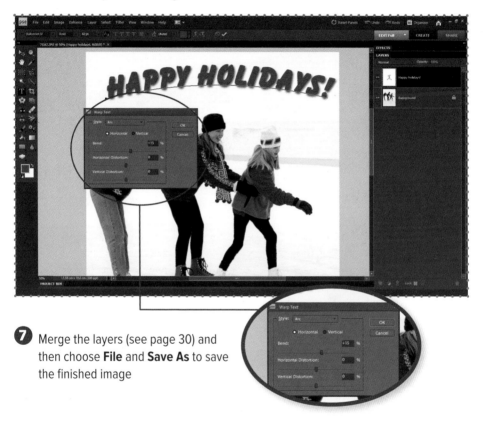

7 Merge the layers (see page 30) and then choose **File** and **Save As** to save the finished image

⏵ Get Creative

CREATE TEXT EFFECTS

Using the Type Mask tools you can create great fun effects such as text filled with an image or cut text out of an image so that the background shows through. The Horizontal Type Mask and Vertical Type Mask tools create a selection on the active layer in the shape of the text. You can then move, modify or save this selection.

Create text filled with an image

1 Open the photo onto which you would like to add text

2 Right-click the **Background** layer in the 'Layers' panel. In the pop-up menu, choose **Duplicate Layer...**, then in the 'Duplicate Layer' box that appears on screen give your new layer a name and click **OK**

3 Select the **Horizontal Type Mask** tool from the toolbar

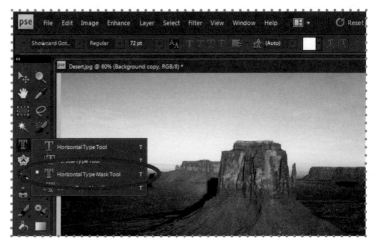

4 In the options bar, choose the type options you wish to use such as font, style and size

5 Click on the photo and type your text

6 When you're done, click the **Commit** button on the options bar. A selection border in the shape of your type will appear

7 From the top menu, click **Select**, then **Inverse**. This deselects your text and selects everything else

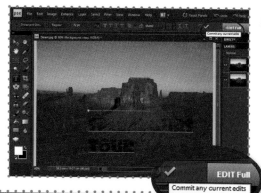

8 Press the **Backspace** key to delete everything outside your selection border. Your type is now filled with your image

9 Click **Select**, then **Deselect**. Click the eye icon next to the 'Background' layer to view just your text, which is now filled with the background image. Click **File** and then **Save** to save the image

▶ Get Creative

CREATE BLUR EFFECTS

Compact digital cameras offer many benefits, but blurry backgrounds and subjects that have a great sense of blurred motion isn't one of them. These kinds of effects are usually the domain of digital SLRs, but PC photo-editing software can replicate these effects with ease.

The trick is to choose an image that will be enhanced by a blurry effect. A good choice is portraiture, where a blurry background would draw focus onto the subject, or a digital photo in which there's a natural sense of movement.

Select the area to be retained

1 Open a photo you wish to transform

2 Make a selection of the main subject – in this case, a family and sledge – using the **Lasso** tool

3 Zoom in to 250% and click and drag the mouse to draw a line around the edges of the main subject. Don't worry if your selection goes a little awry. The next steps explain what to do

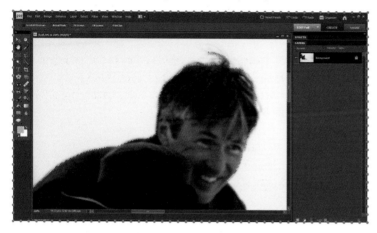

4 Zoom in close on the photo to view the accuracy of the selection. If an area has been missed off, as in this case where the man's shoe needs adding, click on the **Add to Selection** option among the small squares to the left of the Lasso's settings bar. Then click and drag around the unselected area. This will be added to the overall selection once selected

 If you need to remove areas from your selection, click on the **Subtract from Selection** option next to the 'Add to Selection' option and click and drag that specific part of the picture

6 Once the selection is complete, it will appear outlined by a moving dotted line. Softening the selection can make it appear more realistic. To do this, choose **Select** and then **Feather** and give it a value of 3 pixels

Create the blurred area

1 Click **Select** and then **Inverse**. This reverses the selection so that everything in the photo, bar the main subject, is now selected

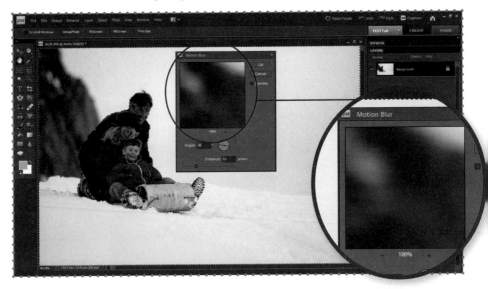

2 Click **Filter**, then **Blur** and then **Motion Blur** so the background can be further blurred. Choose a high value to blur the background thoroughly. Choose an angle that best represents the direction of movement in the 'Angle value' box

3 Invert selection again by choosing **Select** and then **Inverse**. Copy the selection by pressing **Ctrl + C**

4 Create a new layer by choosing **Layer,** then **Layer** and then **Layer** again and call it 'foreground blur' and press **OK**. Paste the copied selection onto it by pressing **Ctrl + V**. Hide the background layer by pressing its **eye** icon in the 'Layers' panel

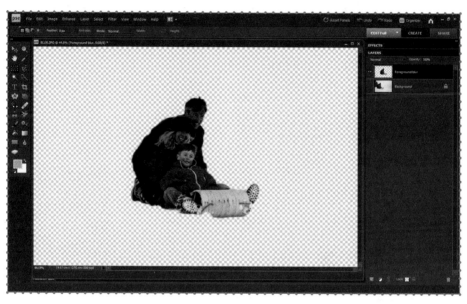

5 Zoom into the main subject on the 'foreground blur' layer. Using the **Quick Selection** tool, select the rear part of the image so that more blur can be added. Once selected, choose **Filter**, then **Blur** and then **Motion Blur** and enter a value halfway between the blur value used in Step 2, opposite, and zero

6 Repeat Step 4, but expand the area to include more of the foreground of the main image. Click **Filter**, then **Blur** and then **Motion Blur** and enter a lower value halfway between zero and the value used in Step 4

7 Select the lower layer, and hide the 'foreground blur' layer by clicking on its **eye** icon. Using the **Quick Selection** tool, select the rear of the main subject and apply another motion blur

▶ Get Creative

8 Position the top 'foreground blur' layer over the main subject of the lower layer (ensure both eye icons are on)

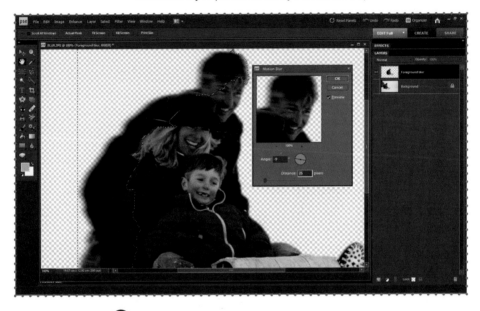

9 Merge the layers (see page 30) and then choose **File** and **Save As** to save the finished image

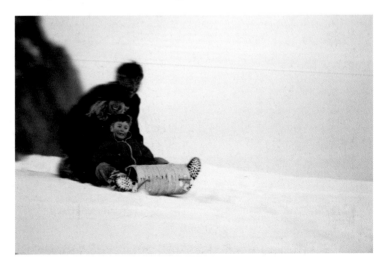

APPLY LIGHTING EFFECTS

Light is the most important consideration when taking photographs, but outside of a studio it doesn't always behave as expected. Photoshop Elements gives a lot more control over lighting after a photo has been taken. Both ambient lighting and direct lighting can be changed.

Brighten a photo

1 Open a photo you wish to transform

② Click **Enhance**, then **Adjust Lighting** and then **Levels**. Select the pipette icon that has a white dropper and click on an area of the photo that should be white. Once done, click **OK**

Layers and lighting

① Choose **Layer**, then **Duplicate Layer** from the menu. This will make a new layer appear. (See pages 28–30 for more on layers)

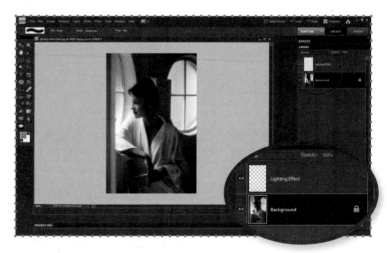

2 Rename the new layer 'Lighting Effect' and click on **OK**. It will automatically become the topmost layer

3 With this topmost layer selected, open the 'Lighting Filter' by clicking **Filter**, then **Render** and then **Lighting Effects**. This filter is like a self-contained program and by using it you can achieve lots of different lighting effects, from simulated spotlights to washing an image with soft, omni-directional light. Try out the different effects until you achieve the result you want

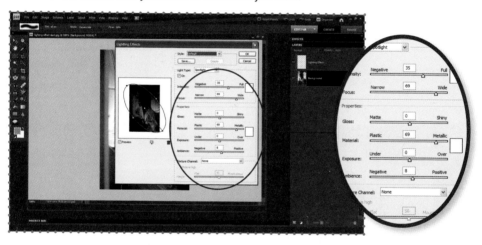

4 Use the preview pane on the left side of the filter's box to see how an image will appear if you apply the filter using the current settings

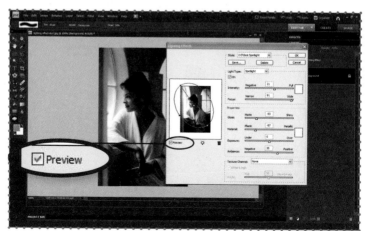

5 Use the right side of the filter's box to pick other lighting styles and apply further adjustments. It is divided into four sections:
- ▶ 'Style' for choosing the kind of light you want
- ▶ 'Light Type' controls the light's area of coverage
- ▶ 'Properties' controls reflection and brightness
- ▶ 'Texture Channel' for adding texture to a lighting effect

Move the sliders to left and right to experiment with the different changes you can make to the photograph

Work with 'Style' to create different lighting effects

1 Click on **Style** to bring up a long menu of preset lighting effects. In this case '2 O'Clock Spotlight' was chosen. It uses a spotlight to focus the light onto a point, which will be used to give the impression of more light streaming in through the window

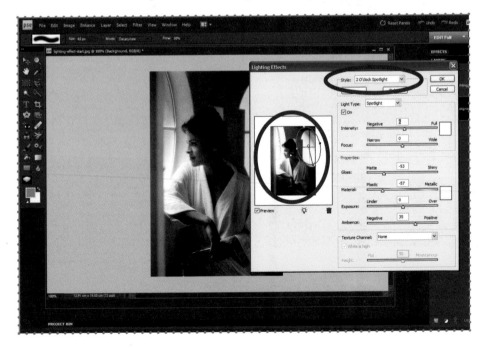

2 Using the mouse, position the centre of the spotlight circle on the subject's face and drag the edge of the circle to the top-left of the preview image. Adjust 'Intensity' to suit, and increase the 'Ambience Value'

3 To add a further light use the mouse to click and drag the light bulb in the lower part of the preview area onto the image. In this case, it was placed over the second window, adjusting to suit. Click **OK** to accept the settings

Before

After

4 Merge the layers (see page 30), then choose **File** and **Save As** to save your image

▶ Get Creative

CREATE A PANORAMIC PHOTO

Photographing a stunning vista or cityscape is often simply too massive to squeeze into a single photo, but by stitching together a series of photographs you can create a superwide photo known as a panorama. You can do this in two ways:

 Using 'Panoramic' mode. Be cautious, however, as some digital cameras will simply trim the top and bottom off a standard-size photo, creating a false panoramic scene

 Take lots of overlapping photos and use photo-editing software to place these photos next to each other to create a long

photo. This is known as photo stitching, and most modern photo-editing software has tools to create panoramas

Taking photos for panoramas

▶ Take lots of photos of the scene while panning the camera. Ensure that each photo overlaps the next by at least a quarter
▶ To get the best shots, it's best to use a tripod to keep the camera level as you take each picture
▶ Keep to static scenes. A series of photos of a seafront, for example, would feature lots of wave movement, making it very difficult to stitch the photos together later on

Automatically create a panoramic scene

Photo-editing software such as Photoshop Elements has special tools to automatically stitch together photos to create a panoramic scene. The great news is that it is often highly automated.

1 Name each photo file to be used for the panorama in sequential order from left to right, such as '1_city', '2_city', '3_city' and so forth

2 Open all the images that make up the panoramic scene. In this case, six photos are used. To select all the photos, press **Ctrl** and click on each of them, and then click **Open**

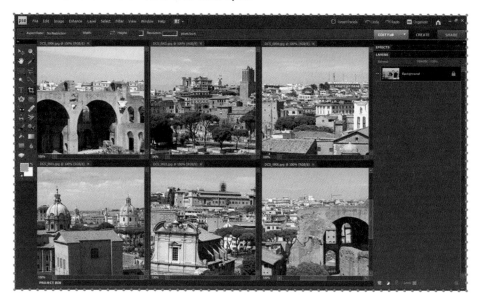

▶ Get Creative

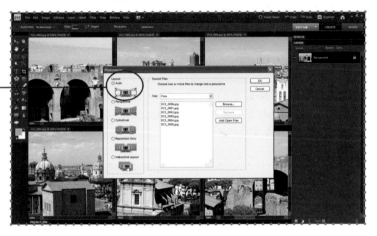

❸ Click **File**, then **New** and then **Photomerge Panorama**. In the screen that appears, choose **Add Open Files**. Ensure that **Auto** is selected in the upper-left of the screen. Click **OK** when done

❹ The photo-editor will then attempt to align the photos and blend them together into one scene, as below. If you get a near perfect result, use the **Crop** tool to cut away the edges of the scene to produce the finished result (see pages 42–4)

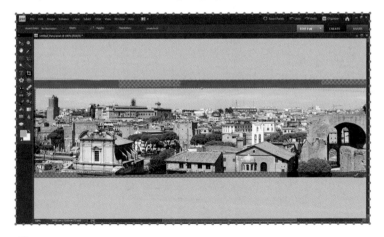

❺ Flatten the image in the **Layers** palette (see page 30), then choose **File** and **Save As** to save the completed panoramic scene

Manually create a panoramic scene

Sometimes automatic panoramic software will create a scene that doesn't look quite right. Photoshop Elements allows photos to be manually aligned, often resulting in a better fit.

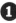 Open all the images that make up the panoramic scene. In this case, six photos are used (see page 125)

2 Click **File**, then **New** and then **Photomerge Panorama**. In the 'Photomerge' window, select the **Interactive Layout** option. Click **Add Open Files**, and then **OK**

3 In the interactive layout window, drag and drop the photos into the main layout window, as shown below, aligning them in sequence. Ensure the 'Reposition Only' option is selected in the 'Settings' box, and that 'Snap to Image' is ticked

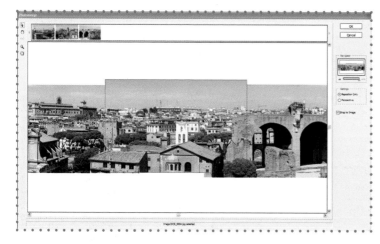

TRY THIS
Sometimes photos that are stitched together may contain glitches where elements don't quite overlap well. Use the guide to repairing old photos on pages 138–9 for some handy techniques on fixing these imperfections.

4 Using the **Selection** tool, reposition the images as needed, clicking **OK** when done. Crop the image as needed (see pages 42–4)

5 Merge the layers (see page 30) and then choose **File** and **Save As** to save the finished image

▶ Get Creative

CREATE A COMPOSITE PHOTO

One of the most powerful ways to use photo-editing software is to merge parts of different photographs to create a new image. Taking an element from one photo and adding it to another is called 'compositing', although it is also referred to as 'photo montage'. This technique is useful for adding people or objects taken from one photo to another one and the following steps explain how to do it:

Choose the parts you want to merge

 Open the two photos you would like to combine. The first photo will be the background scene, while the second photo contains the element to be added to it

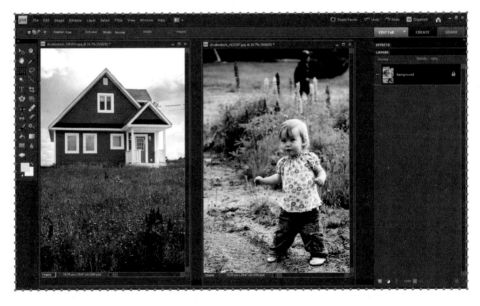

❷ To show the two photos side by side, click **Window**, then **Images** and then **Cascade**

3 Select the window containing the foreground element to be added to the background photo. Double click the **Hand** icon to make this photo fill the screen as much as possible

Isolate the main element to be moved

1 Click **Image** and then **Magic Extractor...** and a new screen appears

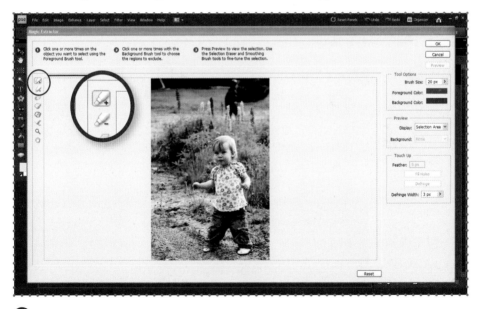

2 Use the **Foreground Brush** tool to colour over areas that you want to keep, in this case the child and path, and use the **Background Brush** tool to tell the photo-editor the areas you want to exclude. Red areas will be saved, while blue areas will be removed. Once happy, press **Preview** to see the effect

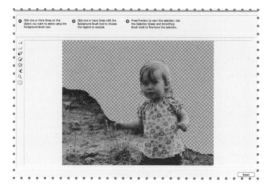

3 The preview image shows a checked background that will become transparent, in effect removing it from the photo. This means that when you move the foreground element over to the background photo, it will seamlessly appear as part of the photo. If the effect looks good, press **OK**

TRY THIS

Another way to isolate the main element is to use the Eraser tool to remove the background. Choose the **Background Eraser** tool from the toolbar. Click on the background holding down the **Alt** key to 'sample' the colour you wish to erase. Drag your mouse along the area to remove – only the colour you sampled will be deleted.

4 Choose the **Rectangular Marquee** tool and draw a square around the object you want to add to the background photo. Once selected, it will be surrounded with an animated line

Combine the images

1 To make both images visible, click **Window**, then **Images** and then **Cascade**

2 Select the **Move** tool, then click and drag the selected foreground element from its original photo across the screen onto the background photo. Minimise the second photo so you can just see the background photo

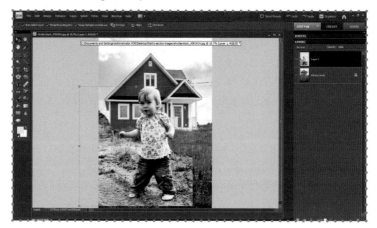

3 Using the **Move** tool, click and drag the foreground element around the photo, placing it where you need to

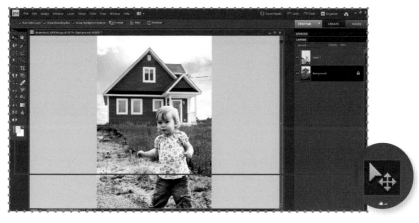

4 If the cut-out element is too big or small, tick the **Show Bounding Box** in the options bar. Click and drag a corner of the bounding box that appears around the cut-out foreground object to resize it. Press the **green tick** to commit to the resize, or press the **red cross** to abandon the resizing of the foreground element

5 Merge the layers (see page 30) and then choose **File** and **Save As** to save the finished image

▶ Get Creative

ADD A 3-D EFFECT TO A PHOTO

One of the great things about digital photos is the ability to use them in lots of fun projects such as scrapbook pages, greeting cards and photo collages. Here's a great technique for giving a 3-D curl look to your photos when placing them on a 'Background' layer. Try it when making digital cards, calendars, scrapbooks or photo albums.

In this example, a photo is going to be placed on one of Photoshop Element's themed backgrounds (these can be found in the 'Content' panel accessed via the 'Window' drop-down menu).

Choose a background

 Click **File**, then **New** and then **Blank File**. In the dialog box that appears type in the width and height of background. You can keep the default size or choose a specific size to suit your project. Click **OK**

2 From the top menu, click **Window**, then **Content**. This will open the 'Content' panel on the right-hand-side of the window

3 In the 'Content' panel select **Backgrounds** from the drop-down menu if it isn't highlighted by default

4 Choose a background and double-click it to open it in the main window. In this example, 'Beach with Seashells' has been used. Hover your cursor over a background thumbnail to see its name

5 Click **File**, then **Open**

6 Select the photo you want to work on and click **Open**

7 Click the themed background image and then drag the photo from the project bin so it sits on top. It will appear as a new layer in the 'Layers' panel. If necessary, resize the photo

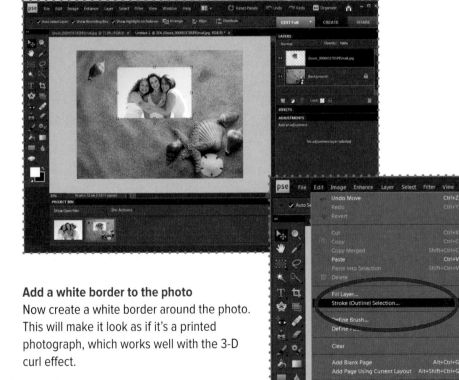

Add a white border to the photo
Now create a white border around the photo. This will make it look as if it's a printed photograph, which works well with the 3-D curl effect.

1 With the photo selected, click **Edit**, then **Stroke (Outline) Selection...**

2 In the 'Stroke' dialog box that appears, type in a stroke width and select a colour for the stroke. In this case, white is being used – which is selected by default. Make sure that **Inside** is selected under 'Location'. Leave the other options in the dialog box as is and ensure the Mode is 'Normal'. Click **OK**

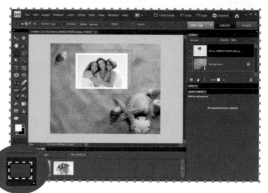

3 Select the **Rectangular Marquee** tool and draw around the photo as shown

Make the photo appear to curl

1 With the photo layer selected, click **Filter**, then **Distort** and then **Shear...**

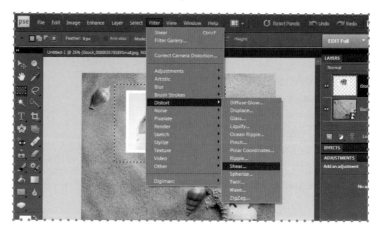

2 In the 'Shear' dialog box, click the middle of the black line in the grid window and drag it slightly either to the left to create a left curl or to the right for a right curl. Be careful not to drag it too far as this will create an unrealistic effect. You can see a preview in the panel below

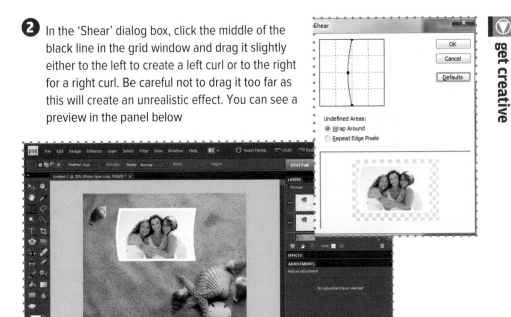

3 Click **OK** to apply the 'Shear' to the photo

4 From the top menus, click **Select**, then **Deselect**

Add a shadow

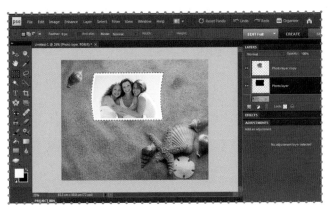

1 In the 'Layers' panel, click and drag the photo layer onto the **New Layer** icon, which is the small square with a raised corner bottom left of the 'Layers' panel. This will create a copy of the photo layer

Get Creative

2 Select the original photo layer. Then hold down the **Ctrl** key and click inside the small thumbnail image of the photo on the layer. This makes a selection of just the photo

3 On the toolbar check that the 'Background colour' is black

4 Hold down the **Shift + Ctrl** keys and then press the **Backspace** key. Ensure the 'Contents' box reads as 'Background Color' and click **OK**. This will make the selection black – thus creating a shadow

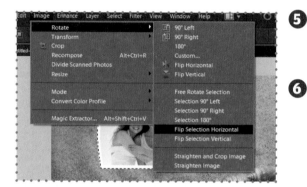

5 Now flip the selection. Click **Image**, then **Rotate** and then **Flip Selection Horizontal**

6 Select the **Move** tool, then click and drag the flipped black selection to create a shadow effect

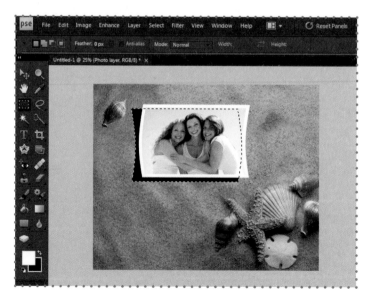

7 In this case, the black selection is positioned to the left and down slightly below the photo. This makes the photo look as if it's curling away from the background

8 Click **Select**, then **Deselect**

Adjust the shadow

As the black shadow looks a little harsh, add a Gaussian blur to soften
it and then reduce the
opacity of the shadow
layer. This will create a
more realistic effect.

1 With the 'Photo
layer' highlighted,
click **Select**, then
Deselect to deselect.
Then click **Filter**,
then **Blur**, and finally
Gaussian blur...

2 In the 'Gaussian Blur' dialog box, drag the slide to the
left to adjust the blur. Then click **OK**

3 Make sure the shadow layer is selected and then drag
the slider to the left to reduce the opacity as desired

4 Your 3-D curl effect is now complete. Save the file by
clicking **File**, then **Save** or carry on working to add
text (see pages 109–13) and other effects

▶ Get Creative

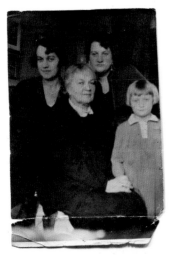

REMOVE DAMAGE FROM OLD PHOTOS

Digital photography doesn't mean you have to discard photos taken long before the invention of digital cameras. Long-lost and damaged photos that you may have lurking in old shoe boxes can be given a new lease of life thanks to photo-editing software.

Scan your photograph

Scan your old photograph using a scanner or all-in-one printer. Scan it in as a high a resolution as possible, as you can then enlarge the photo (which is likely to be small) to a larger 15 x 12cm (6 x 4in) print. Follow the instructions on your scanner to get the best results. Save the photo as a JPEG file and open the scanned photo in Photoshop Elements.

Straighten your photograph

It's likely the the scanned image isn't perfectly straight. In order to straighten it, click **Image**, then **Rotate** and then **Straighten Image**.

Fix damaged areas

❶ If there's an area that is badly damaged, you may want to crop it out. Select the **Crop** tool and draw a square around the area of your photo you want to keep; when you're happy with your selection click the green **commit** icon (for more about cropping, see pages 42–4)

2 The Spot Healing Brush tool is ideal for removing minor flaws from photos, such as the scratch at the upper left-hand corner. Zoom in on the area you want to repair and click on the **Spot Healing Brush** icon. Hold down the left-hand button of your mouse and drag it across the area that you want to fix (see pages 82–4)

3 To fix bigger areas of damage, such as around the bottom of the photo, click on the **Clone Stamp** tool. Chose a medium-sized 'Basic Brush' from the options bar for the repairs. Position the cursor in the area of the picture to copy. Hold down the **Alt** key and click with the left-hand button on the mouse. The cursor will change to an icon that looks like a bullseye

4 Position the mouse over the damaged area and click again to paste the copied section. Repeat until all damaged areas are repaired. Continue to use both tools to repair other areas

⊙ Get Creative

RESTORE COLOUR IN AN OLD PHOTO

Along with repairing scratches and tears (see pages 138–9) in scanned photographs, Photoshop Elements makes it easy to restore colour to old snaps that have faded or become discoloured. Using the 'Quick Fix' tools, repairing an old photo's colour can be done in a flash.

① Open the photo you wish to restore colour to

② Click the orange **EDIT Full** button on the right and from the drop-down menu click **EDIT Quick** to open the 'Quick Fix' workspace

③ Using the drop-down box labelled **View**, select either 'Before & After – Horizontal' or 'Before & After – Vertical' depending on which fits your photo best. Here, 'Horizontal' has been chosen

4 To restore the photo's colour, click the **Auto** button in the 'Smart Fix' panel under the 'Quick Fix' tab. The after picture will change to a more realistic colour

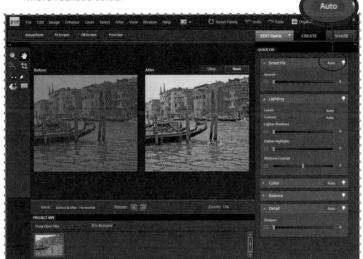

5 Alternatively, drag the 'Smart Fix' slider towards the middle to fine tune the colour change manually. You can keep tweaking the end result by

moving the slider. Moving the slider to the right will boost the blues and greens in the photo while moving it to the left will increase the red and yellow colours

6 When you're happy with the result, click the **Commit** (tick) icon that appears at the top of the 'Smart Fix' panel to apply the changes you have made

▶ Get Creative

TIP

With some photos you can get an even better result by repeating the 'Smart Fix' process

7 For most photos, using the 'Smart Fix' slider will produce great results, but if your photo appears a little dark you can use the 'Lighting', 'Color' and 'Detail' tabs in the 'Quick Fix' panel to make further adjustments.

▶ For example, if necessary, use the 'Lighten Shadows' and 'Darken Highlights' sliders to adjust the brightness of the photo, and then the 'Midtone Contrast' slider to increase the contrast slightly

▶ Use the 'Color' sliders to change the atmosphere of an image, making it warmer in tone for example

▶ The 'Sharpen' slider will bring greater definition to slightly fuzzy photographs printed with old inks that have blurred over time

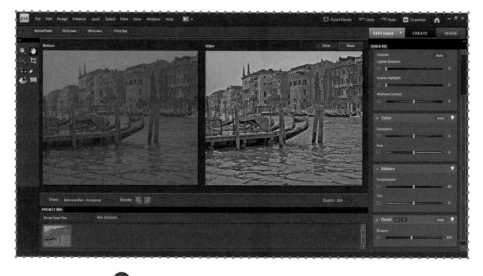

8 For each adjustment remember to click the **Commit** (tick) icon to confirm the changes

9 When you're finished, click **File**, then **Save** to save your restored photo

MAKE A VINTAGE PHOTO

You can easily recreate a bygone era by quickly aging photos with Photoshop Elements. This handy tutorial shows how to add an authentic old-fashioned look to any photo using a combination of several filters and Photoshop Element's 'Quick Fix' feature.

Prepare the photograph

1 Open the photo you wish to work on, then right-click the **Background** layer in the 'Layers' panel. In the pop-up menu, choose **Duplicate Layer...**, then click **OK** in the 'Duplicate Layer' box that appears on screen

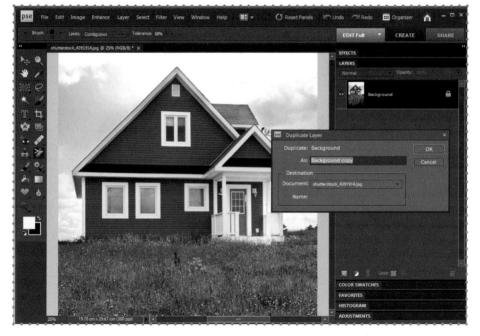

2 Click the **Eye icon** to the left of the 'Background' layer in the 'Layers' panel to turn off the visibility of the 'Background' layer

3 Click the orange **EDIT Full** button on the right and from the drop-down menu click **EDIT Quick** to open the 'Quick Fix' workspace

4 In the 'Quick Fix' panel on the right-hand side, move the 'Saturation' slider to -100 to make the image greyscale

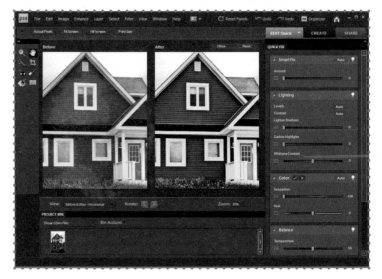

5 Move the 'Lighten', 'Darken' and 'Midtone Contrast' sliders to increase the contrast of the image, which you'll need to gauge by eye. Once done, click **EDIT Full** to return to the 'Full Edit' workspace

Add a sepia filter

1 Ensure the greyscale layer is still selected, then click **Filter**, then **Adjustments**, and finally **Photo Filter...**

2 In the 'Photo Filter' box that appears, choose **Sepia** as the 'Filter' type, and set the **Density** to a value of 80%, and ensure **Preserve Luminosity** is ticked. Click **OK**

3 Choose a brown foreground colour, and a white background colour

4 Click **Layer**, then **New**, and then **Layer...** to create a new layer at the top of the layer stack

5 Click **Filter**, then **Render** and then **Clouds** to create a layer filled with a brown-white cloud effect

6 Click **Filter**, then **Blur** and then **Motion Blur...**

7 Set the angle to 90 degrees, and move the 'Distance' slider all the way to the right. Click **OK**

8 In the 'Layers' panel, set the 'Blending Mode' pop-up menu (this will most likely be reading as 'Normal' and is situated above the layers; click on the down arrow to the right of the box) to **Overlay**, and 'Opacity' to 80%

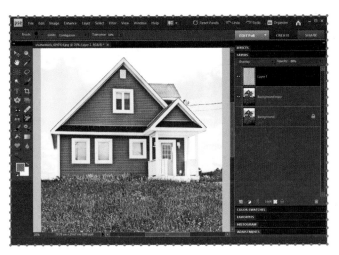

9 On the top menu, click **Layer**, then **Flatten Image**. Save the final image by clicking **File**, then **Save**

▶ Get Creative

CREATE A POP ART-STYLE PORTRAIT

If you're a fan of the iconic Marilyn Monroe image by Andy Warhol, here's an easy-to-follow tutorial that will help you to create your own Pop Art portrait.

Prepare the cut out

 Open the file you want to work on

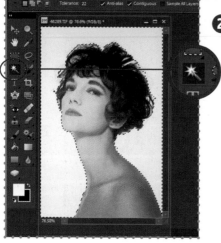

② First remove the background using one of the selection tools. If the background is a single colour, as with this example, use the Magic Wand tool. Click the **Magic Wand** in the toolbar and then click the background. If necessary, adjust the 'Tolerance' value in the options bar to pick up all of the background colour pixels. Here the tolerance is set to 22

3 From the menu at the top, click **Select**, then **Inverse**. This switches the selection from excluding the face and neck to including it

4 Again from the menu at the top, click **Edit**, then **Copy** to copy the selection

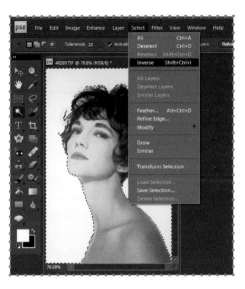

TIP
Printed on canvas, these Pop Art-style portraits make great gifts or a piece of art for your own home.

5 In the 'Layers' panel, click the **Create a new layer** icon. From the menu at the top, click **Edit**, then **Paste** to paste the selection on this new layer

6 The 'Background' layer can be distracting, so if you want to turn it off, click the layer's **Eye icon**. This leaves just the 'Cut-out layer' showing. Click the 'Cut-out layer' to make sure it is selected

Create the Pop Art effect

1 To remove the detail of the face for the effect to work properly, click **Filter**, then **Adjustments** and then **Threshold...**

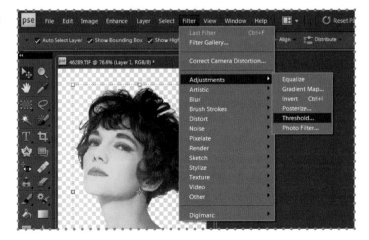

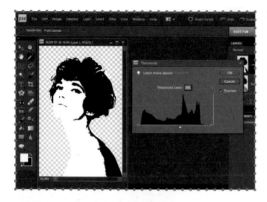

2 The 'Threshold' filter looks at the tones in an image – those lighter than mid-grey are shown as white, while anything darker is shown as black. If the initial effect, as in this case, is too strong with too much white, click the slider at the bottom of the dialog box and drag it to the right. The white areas will begin to be replaced by black. A 'Threshold Level' of around 145 works well here. Click **OK**

3 Hold down the **Ctrl** key and click on the 'Cut-out layer's' thumbnail. This will reselect your selection – you'll see the 'marching ants' outline around its edge

4 Click **Layer**, then **New** and then **Layer....** In the 'Layer' dialog box that appears, name your layer and click **OK**

5 Click **Edit**, then **Fill Selection....** Instead of using a default colour, create a custom colour. In the 'Fill Layer' dialog box, click **Use** and select **Color....** The colour panel will appear. Pick a suitable shade for the subject's skin – in this case an orange colour. Click **OK** to set the colour, and then click **OK** in the 'Fill dialog' to fill the selection

Refine the Pop Art effect

1 As the colour layer sits on top of the original layer, once it's filled with the custom colour, your won't be able to see anything else. To fix this you need to change the way the layer interacts with the layer below using the 'Blend Mode'. Click the **Blend Mode** menu at the top of the 'Layers' panel (it's set to Normal by default) and select **Multiply**. This will apply colour only to the white areas of our portrait

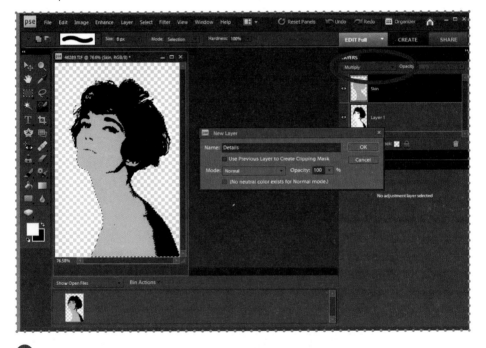

2 Add a little more detail to the portrait. It's best to do this on a new layer so that you can easily correct any mistakes you make. So create and name a new layer as before and set its Blend Mode to **Multiply** so that the colours show through to the original and click **OK**

3 Click the **Brush** tool from the toolbar

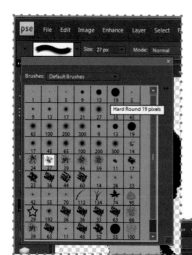

4 In the options bar click the down arrow to open the Brush Picker. Choose a brush with a hard edge such as the Hard Round 19 pixels

5 Start by adding some eyeshadow. Click the **Foreground color** chip in the toolbar to open the 'Color Picker' window. Choose a vibrant, contrasting colour and click **OK**. Brush across the area directly above the eyes. The colour will appear slightly different to the actual colour you chose, because it's mixing with the skin colour

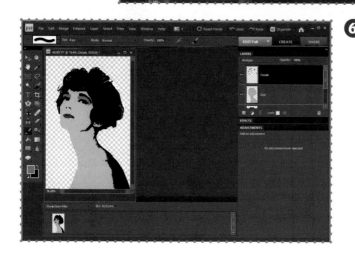

6 Brush in other details by clicking the **Foreground color** chip in the toolbar and choosing suitable colours. In this example, the model's lips are bright red and some deep red highlights have been added around the edge of her hair

7 Now you can paint the whites of her eyes white. However painting with white won't work on this layer as its blend mode is set to 'Multiply'. Instead, you need to remove some of the skin colour to allow the original black and white layer to show through. So, click the 'Skin' layer to make it the active layer. Click the **Eraser** from the toolbar. Select a small brush tip and erase the areas of the eye that you want to be white

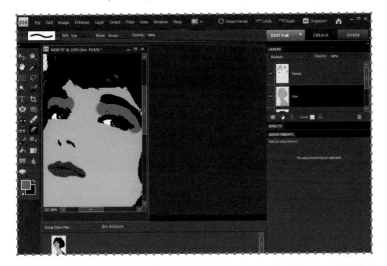

Create a background colour

All you need to do to complete the Pop Art portrait is to create a new background.

1 Click **Select**, then **Deselect** to remove the selection

2 Click the **Background** layer to select it

3 Create a new layer by clicking the **New Layer** icon in the 'Layers' panel. A new layer will appear above the 'Background' layer and beneath the other layers

4 Click **Edit**, then **Fill Layer**. Click on **Use** and select **Color** to open the 'Color Picker' window. Choose a contrasting colour for the background – a green works well here

5 Click **OK** to set the colour and then click **OK** again to fill the layer

6 Your Pop Art portrait is now completed. Click **File**, then **Save** to save the image

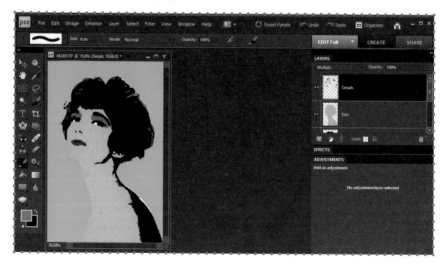

KEYBOARD SHORTCUTS

Pressing the keys	Does this
V	Selects the Move tool
H	Selects the Hand tool
Z	Selects the Zoom tool
L	Selects the Lasso tool
M	Selects the Rectangular Marquee tool
Shift + M	Selects the Elliptical Marquee tool
W	Selects the Magic Wand tool
A	Selects the Selection Brush tool
B	Selects the Brush tool
C	Selects the Crop tool
T	Selects the Type tool
I	Selects the Eyedropper tool
Y	Selects the Red Eye Removal tool
N	Selects the Pencil tool
S	Selects the Clone Stamp tool
E	Selects the Eraser tool
F	Selects the Smart Brush tool
G	Selects the Gradient tool
U	Selects the Rectangle tool
O	Selects the Sponge tool
K	Selects the Paint Bucket tool
J	Selects the Spot Healing Brush tool
D	Sets foreground and background colours to default
X	Switches foreground and background colours
Ctrl + 0	Fits On Screen - displays the entire photo on screen
Ctrl + Alt + 0	Views at 100%
Ctrl + Spacebar	Selects Zoom In tool
Ctrl + Alt	Selects Zoom Out tool
Ctrl + D	Deselects a selection
Ctrl + Shift + D	Reselects last selection
Ctrl + A	Selects everything on current layer
Ctrl + H	Hides selection outline
Ctrl + X	Cuts selection
Ctrl + C	Copies selection
Ctrl + V	Pastes last cut or copied selection
Ctrl + Z	Undo – undoes the last action
Ctrl + L	Adjusts Levels
Ctrl + U	Adjusts Hue or Saturation
Ctrl + Alt + I	Adjusts Image size
Tab	Hides (or shows panels) to make more working room
Ctrl + Shift + E	Merges visible layers
Ctrl + E	Merges down

Artifact A defect or flaw in a digital image.

Aspect ratio The aspect ratio refers to the relationship between the width and height of a digital photograph. For example, if a photo has an aspect ratio 2:1, it means that the width is twice as large as the height.

CMYK The four process colours used in colour printing: cyan, magenta, yellow and black (K).

Colour correction To correct or enhance the colours within a digital photo.

Crop A photo-editing term that means removing a portion of a photo.

Dialog box A window that appears on the computer screen, presenting information or requesting input from the user. A dialog box is also known as a pop-up window.

DPI (Dots Per Inch) A measurement value used to describe the resolution of a display screen or that of a printer. The higher the number, the greater the resolution.

Feathering A technique used to soften the edges of an image in the foreground blending it into the background image with less contrast.

Filter In photo-editing software, a filter is a tool that alters the pixels in a photo to create blurring, sharpening, distortion or other special effects such as transforming a photo into a sketch or painting.

Greyscale A term used to describe an image containing shades of grey rather than colour. Most commonly referred to as a black and white photograph.

Icon A small picture that represents an object or program.

Image resolution The amount of data stored in an image file, measured in pixels per inch (PPI).

ISO (International Standard Organization) In traditional photography, ISO is a measure of the light sensitivity of film, and in digital photography it describes the light sensitivity of the CCD/CMOS. The higher the ISO, the greater the sensitivity.

Interpolation Some cameras and editing software can increase the size of an image by adding pixels between the original ones. They attempt to match the colour and brightness of surrounding pixels to create a seamless image.

Jagged edges When you view a digital photo at a high degree of magnification, the pixels that make up the image appear as tiny squares, resulting in straight lines looking jagged.

Layers A powerful feature of many photo-editing packages, layers are the digital equivalent to laying sheets of tracing paper or transparent plastic over the top of a photo. They can be used to add other images, text or special effects to a photo. Stacked onto each other, each layer can be individually edited, positioned and blended with layers below to create a final picture – all without affecting the original photo, which sits at the bottom of the stack.

Megapixel A measure of the size and resolution of the picture that a digital camera can produce. One megapixel equals one million pixels.

Metadata Information stored within a digital file. Most digital cameras store photos with extra information as standard and some metadata formats such as XMP allow the user to add extra information such as copyright information, captions, credits, keywords, creation date and location or special instruction.

Noise The digital equivalent of film grain. It appears as small, coloured speckles and can detract from picture quality. Noise is worse in digital photos taken in low light.

Pixel (Picture Element) These are the building blocks of a digital photo. If you enlarge an image on a computer, you'll see it is made up of tiny squares, which are the pixels. Digital photos comprise thousands or millions of pixels.

PPI (Pixels Per Inch) A measure of the resolution of a computer display on its monitor or digital image.

Red eye This happens when light from the flash reflects off the blood vessels in the subject's retinae, creating a strange red effect that can spoil a photo.

Resolution The more pixels there are in a digital image, the sharper it will appear. This is the resolution, and is often expressed as two figures that represent the photograph's width and height, such as 1200 x 1600 pixels.

RGB (Red, Green, Blue) Every photograph viewed on a computer is made up of varying amounts of these three colours.

Stitching Combining a series of images to form a larger image or a panoramic photo.

Unsharp masking The process by which the apparent detail and sharpness of an image is increased.

XMP Short for Extensible Metadata Platform, XMP is a standard way for embedding information (metadata) in a digital file, most commonly used on photo files.

▶ Index

index

Index

index

▶ Credits

PICTURE CREDITS

Where there are two or more pictures on the same page, they are from the same source unless otherwise stipulated. Where part of a screenshot, the base image is from the source noted. Screenshots reprinted with permission from Adobe Systems Incorporated and Microsoft Corporation (see page 2).

Courtesy of Digital Vision
Pages 33, 34, 35, 36, 48 bottom, 49, 64, 65, 66, 67, 78, 80, 81,98, 99, 100, 101, 103, 104, 105

Courtesy of iStockphoto
Pages 20, 21, 24, 25, 27, 32, 41 bottom, 42, 43, 44, 85, 86, 87, 124, 125, 126, 127, 132, 133, 134, 135, 136, 137, 140, 141, 142

Courtesy of Microsoft Windows 7
Pages 12, 112, 113

Courtesy of PhotoDisc
Pages 28, 29, 30, 45, 46, 47, 48 top, 82, 83, 84, 109, 110, 111, 114, 115, 116, 117, 118, 119, 120, 121, 122, 123, 146, 147, 148, 149, 150, 151, 152

Courtesy of Shutterstock
Pages 10, 62, 63, 96, 128, 129, 130, 131, 138, 139, 143, 144, 145

Courtesy and copyright of Lynn Wright 2012
Pages 16, 17, 19, 37, 38, 41 top, 50, 51, 52, 53, 54, 55, 56, 57, 58, 59, 60, 68, 70, 71, 72, 73, 74, 75, 76, 77, 88, 89, 90, 91, 92, 93, 94, 95, 106, 107, 108, 112, 113